DKS Art

Fiction Flowers Volume 2,
Coloring Book Of Stress Relieving Mandala Patterns for People Of All Ages

DKS Art
Atlanta, Georgia
United States of America

Copyright © 2019 by DKSArt.com

This work is subject to copyright. All rights are reserved by the Publisher, whether the whole or part of the material is concerned, specifically the rights of translation, reprinting, reuse of illustrations, recitation, broadcasting, reproduction on microfilms or in any other physical way, and transmission or information storage and retrieval, electronic adaptation, computer software, or by similar or dissimilar methodology now known or hereafter developed.

Managing Director: DKS Art
Lead Editor: DKS Art
Technical Reviewer: DKS Art
Coordinating Editor: DKS Art
Copy Editor: DKS Art
Compositor: DKS Art
Indexer: DKS Art
Artist: DKS Art
Photographer: DKS Art
Book Design: DKS Art
Book Layout: DKS Art

For information on artwork, go to www.dksart.com or contact dksartwork@gmail.com

Thank you for buying my coloring book!

For my latest artwork and publications visit

www.DKSArt.com

So grab your favorite markers, colored pencils, crayons or whatever you like to create art with, and add some color to these pages!

Depending on what type of markers you use, you should place a piece of paper under the page you are coloring. To keep the ink from bleeding through the paper onto the next page of this book. Either cut out this page and use it or get another sheet of paper.

Enjoy!

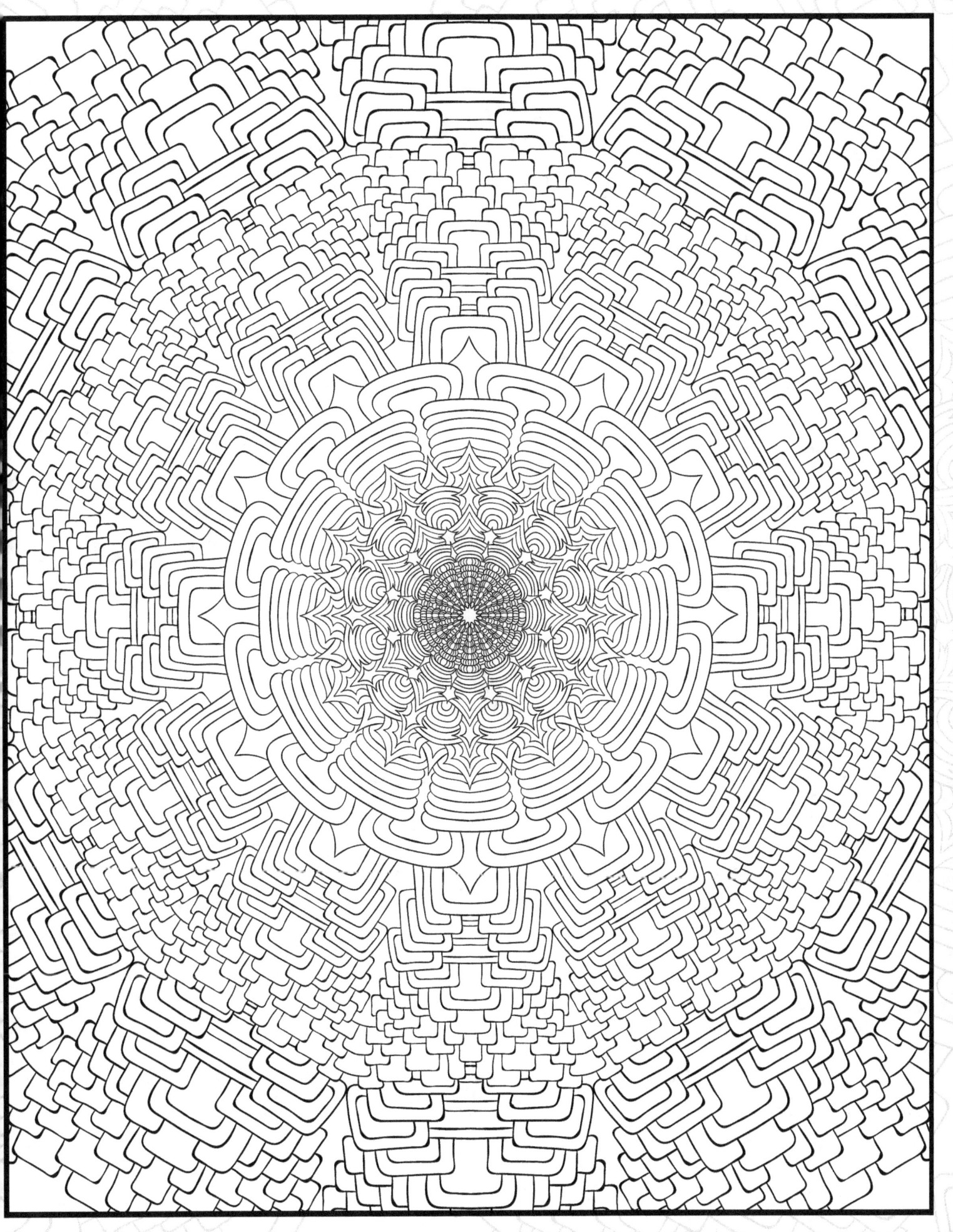

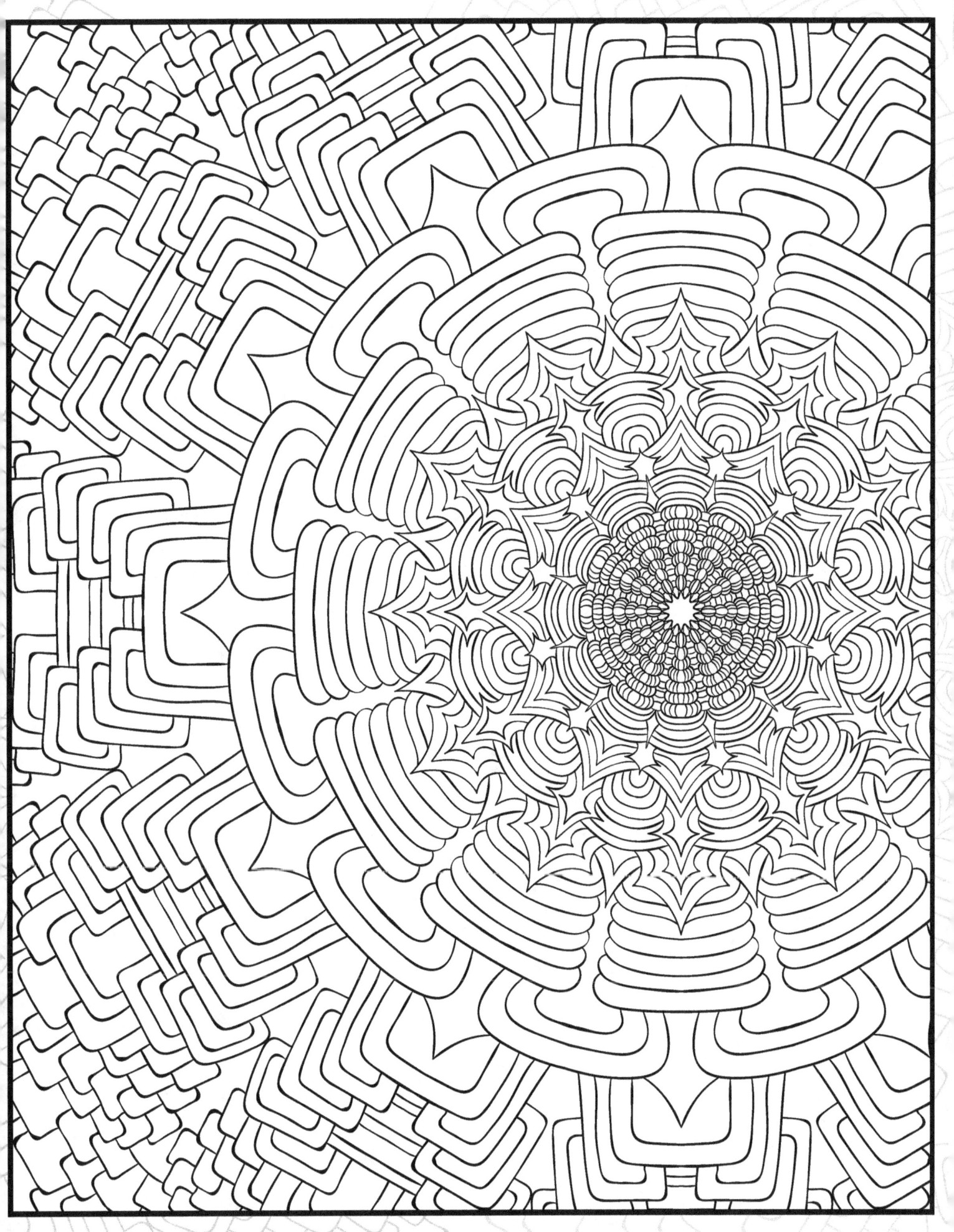

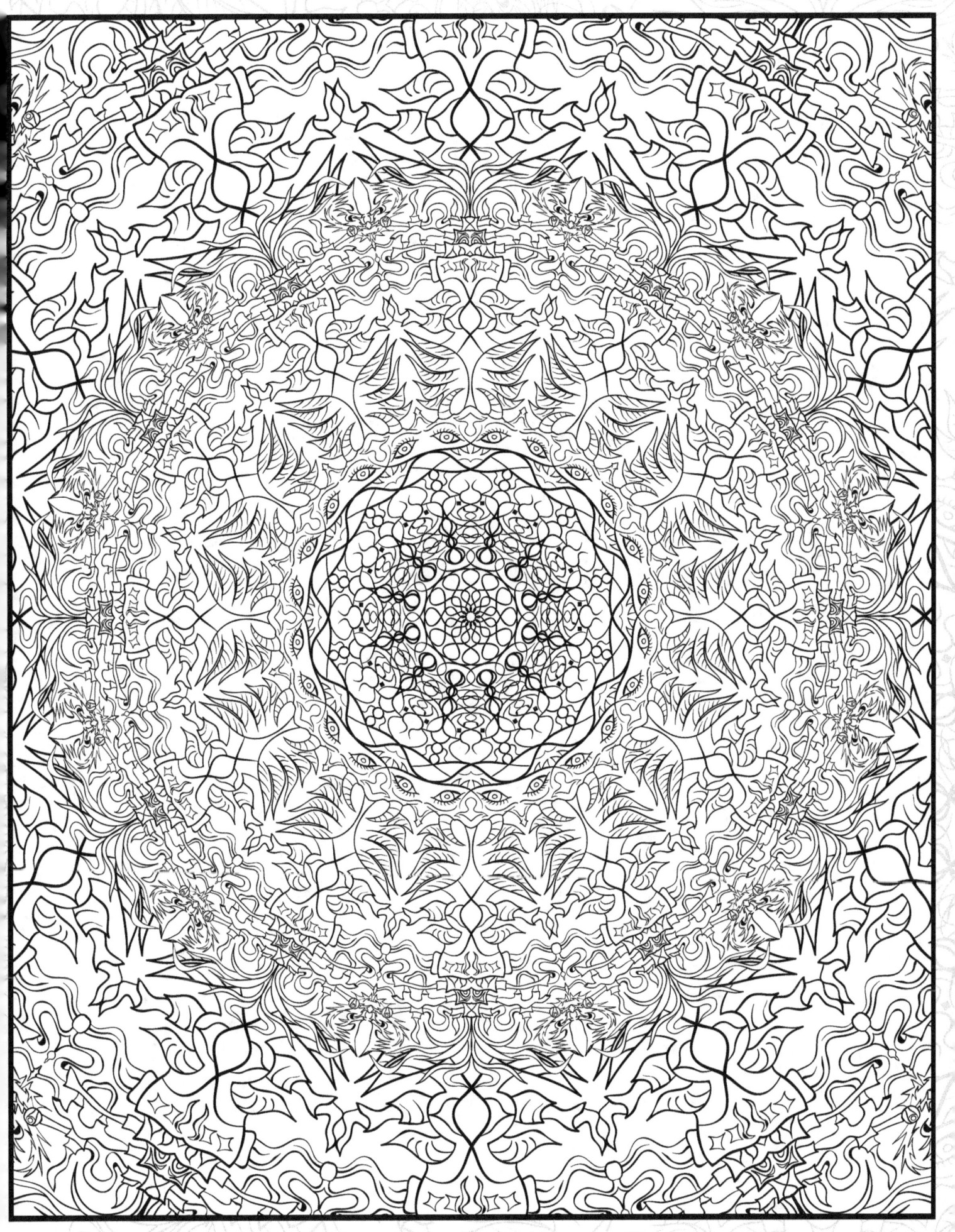

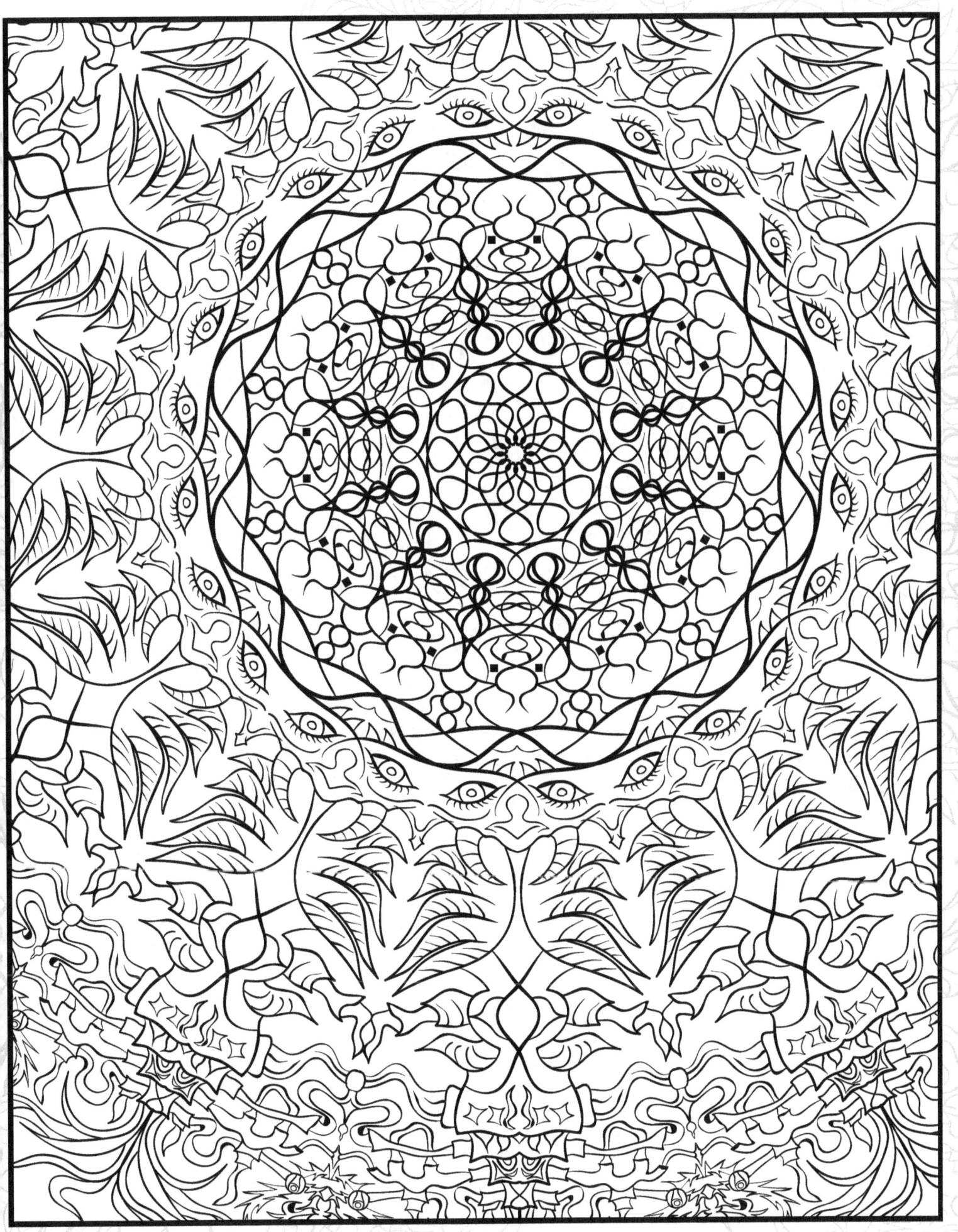

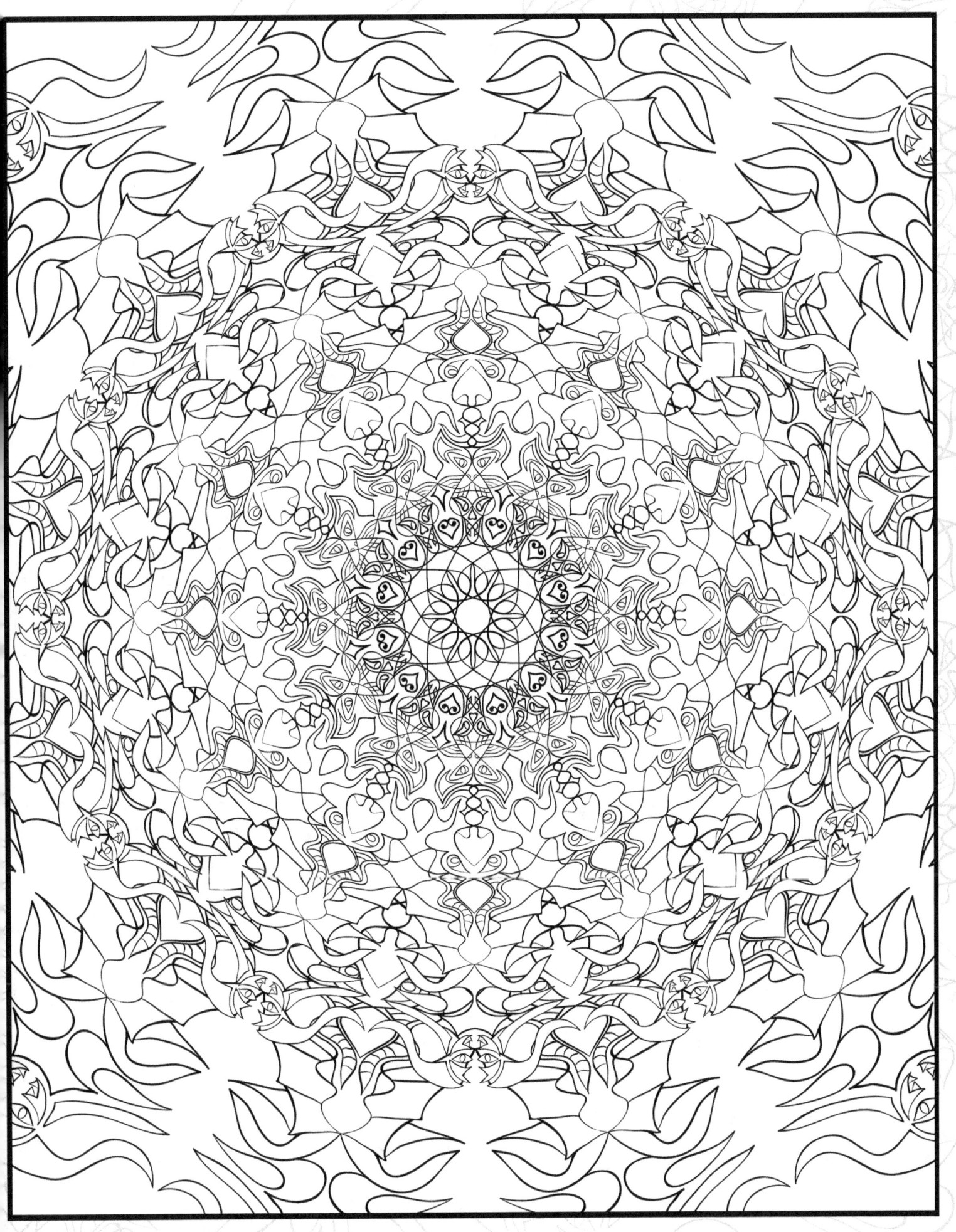

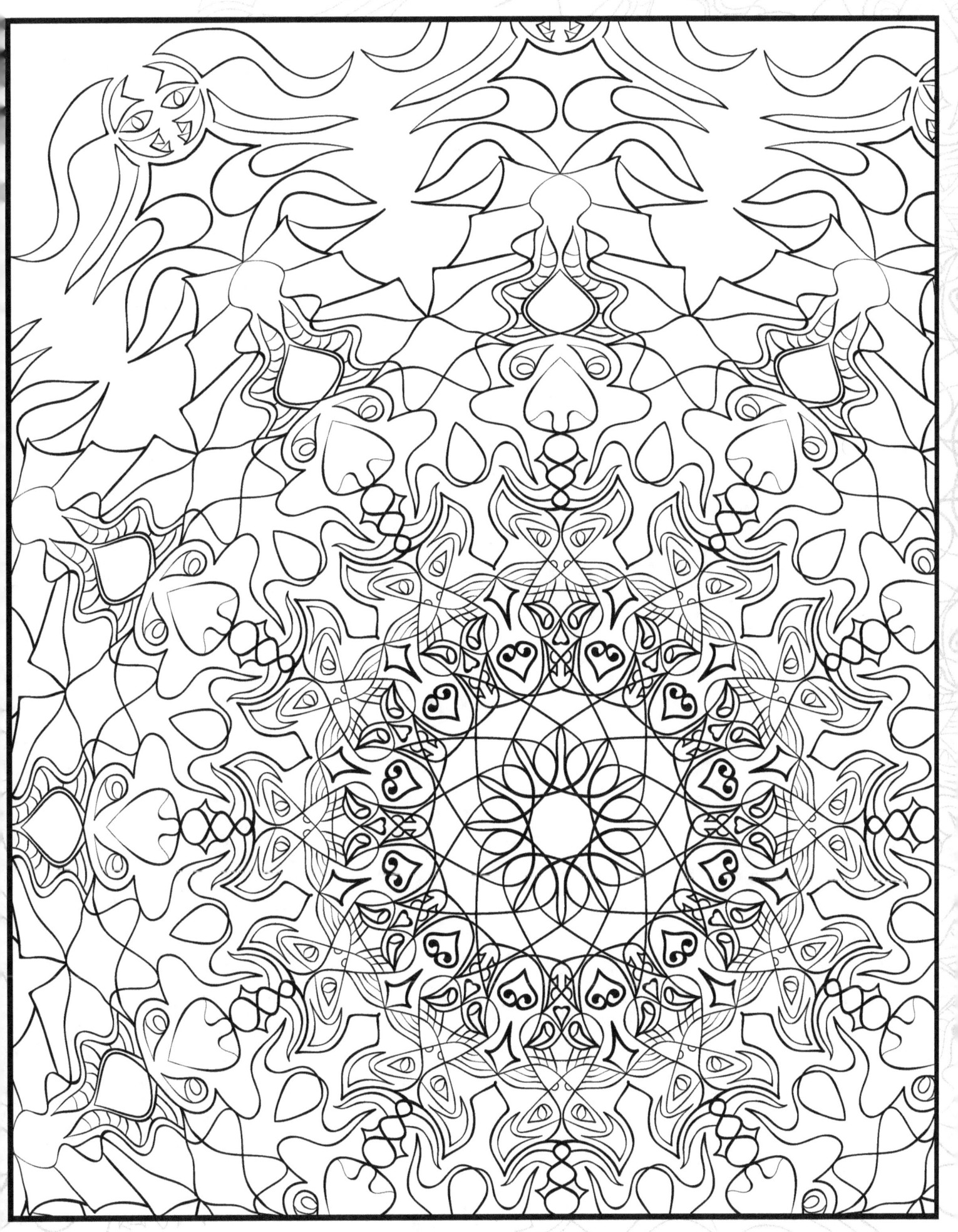

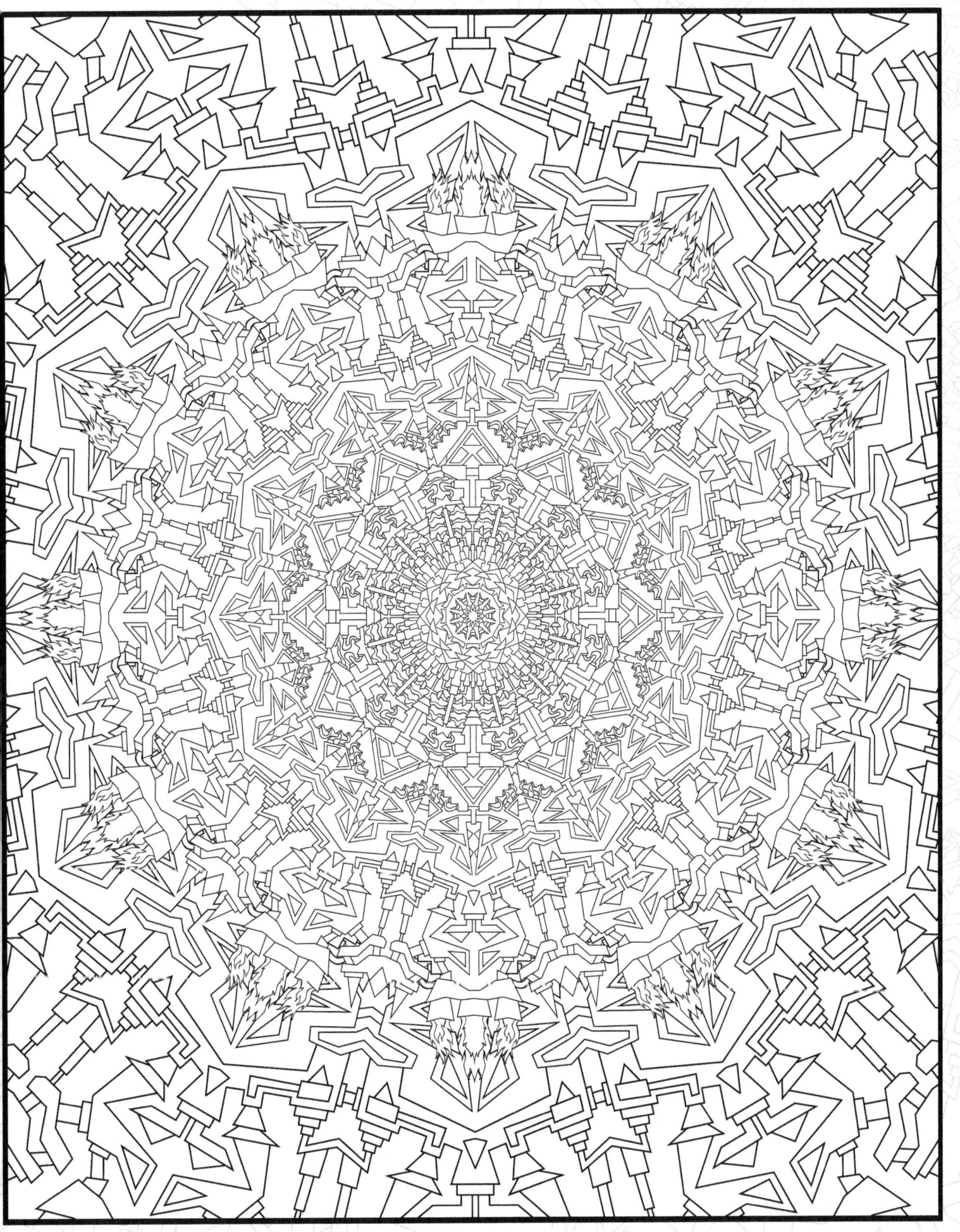

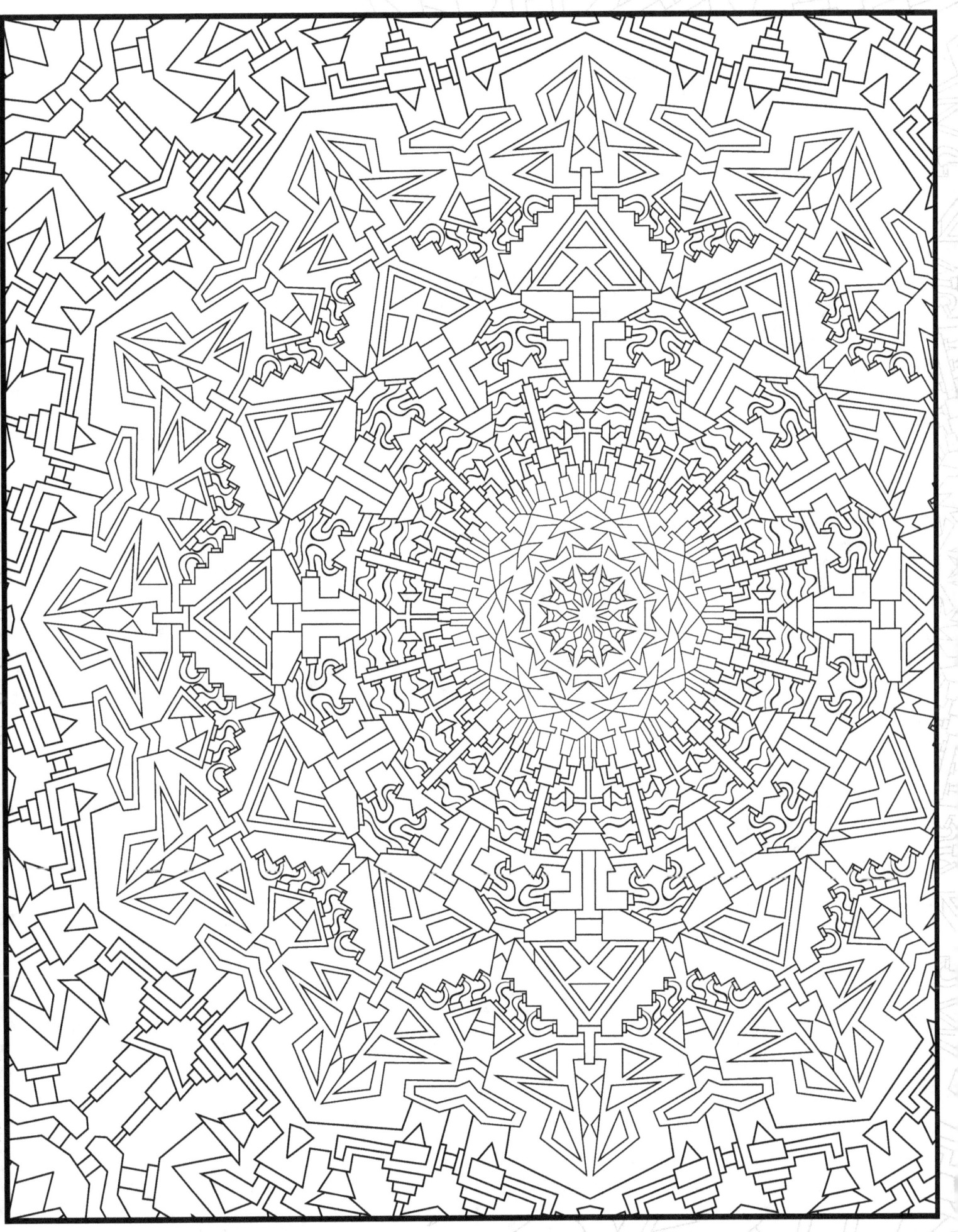

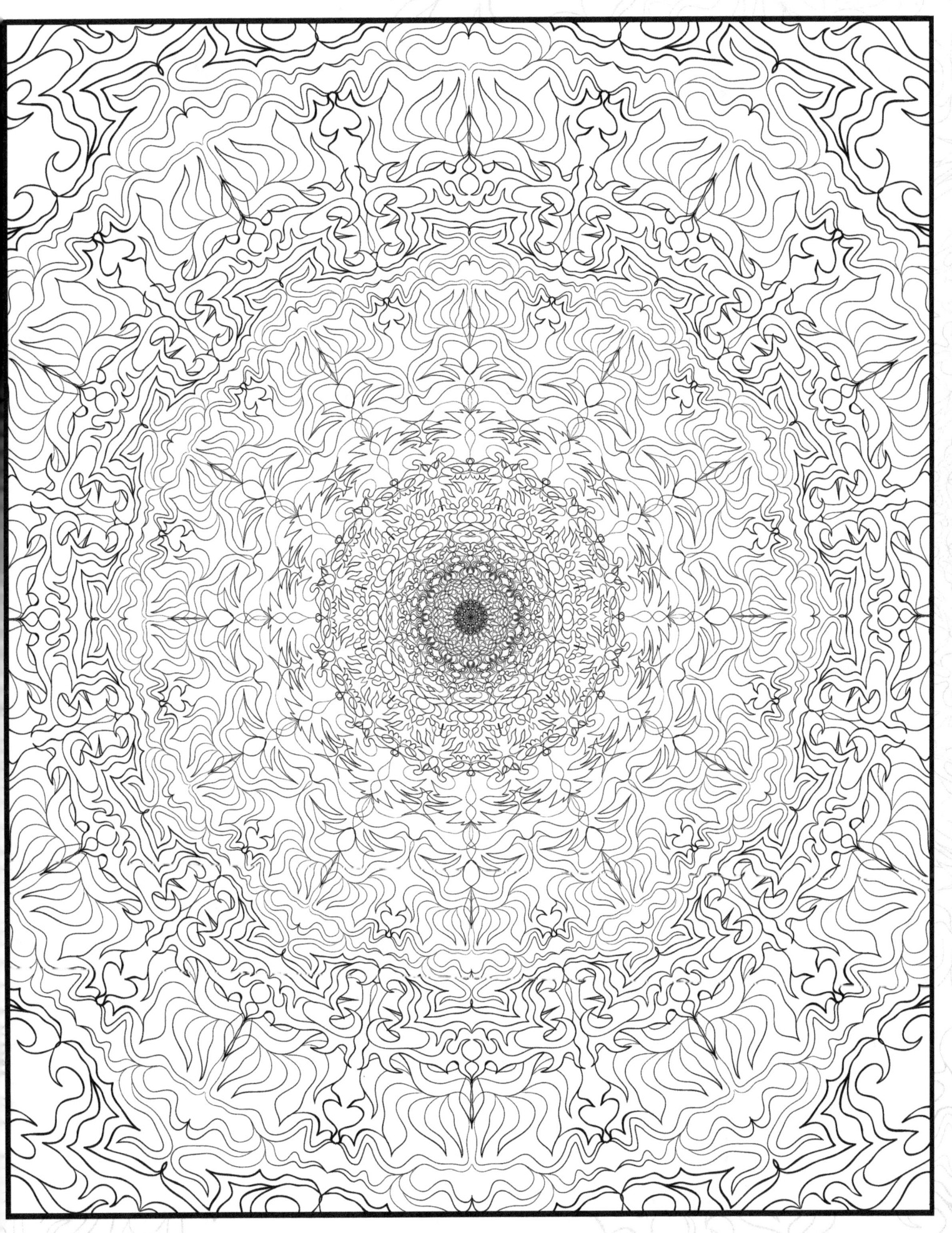

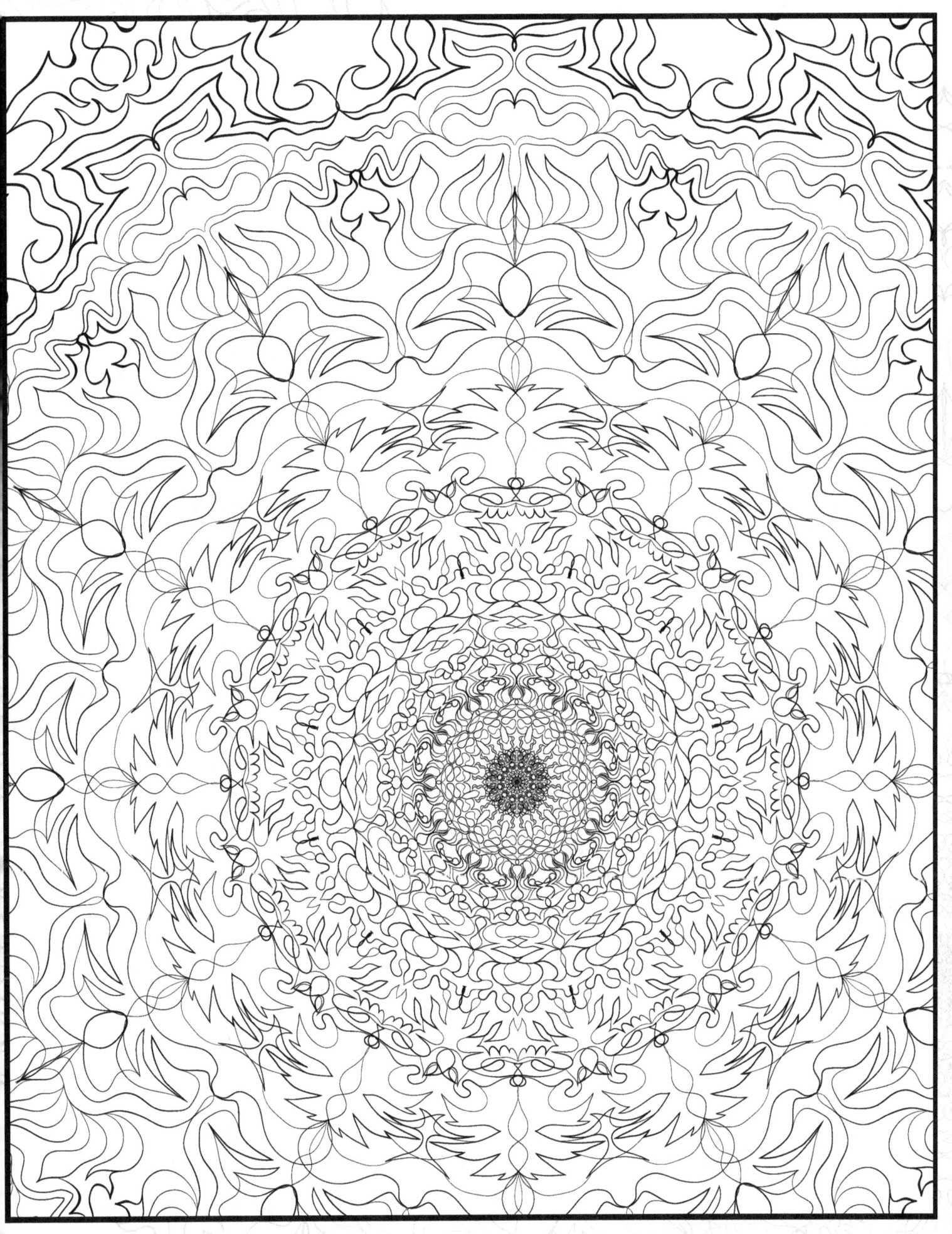

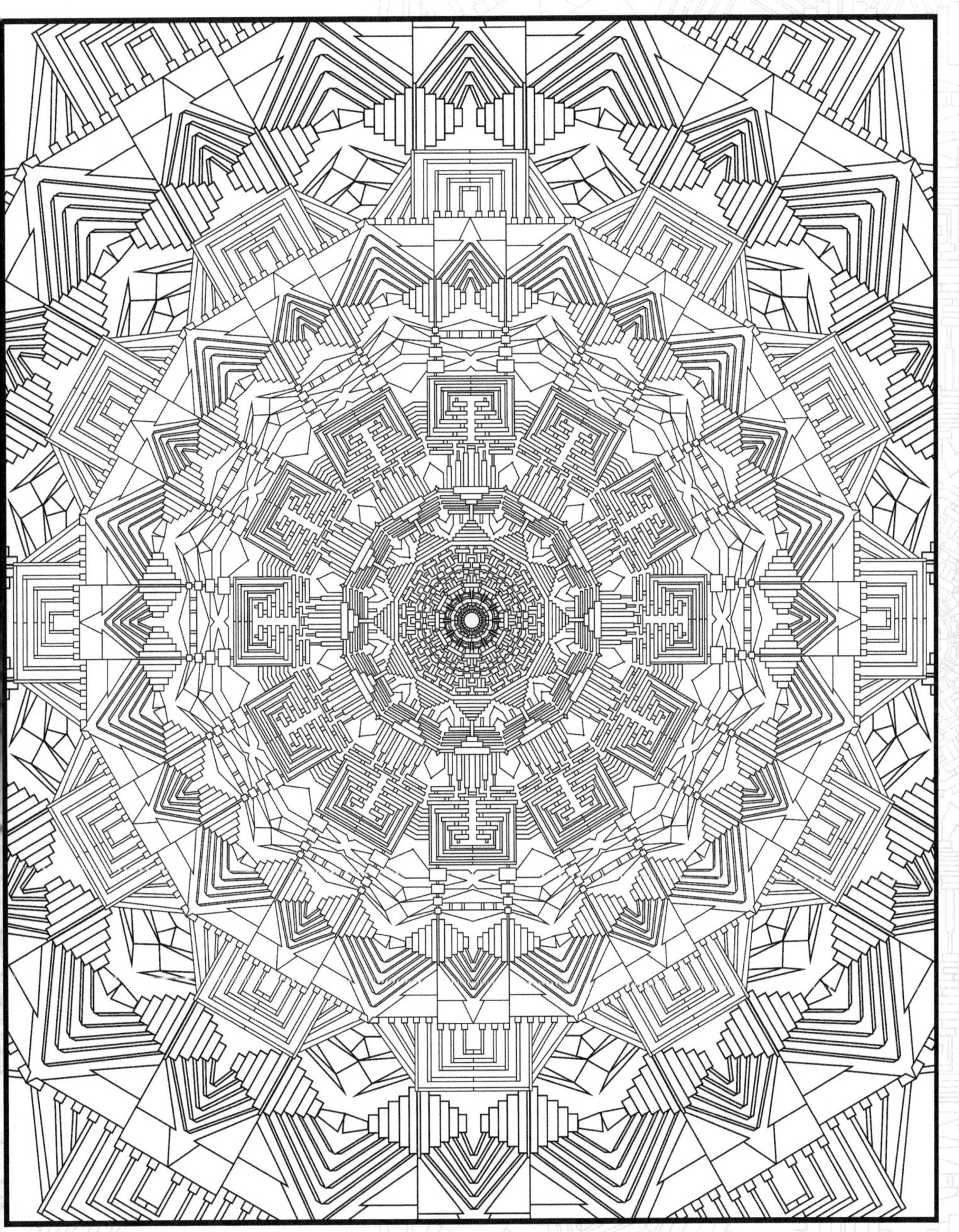

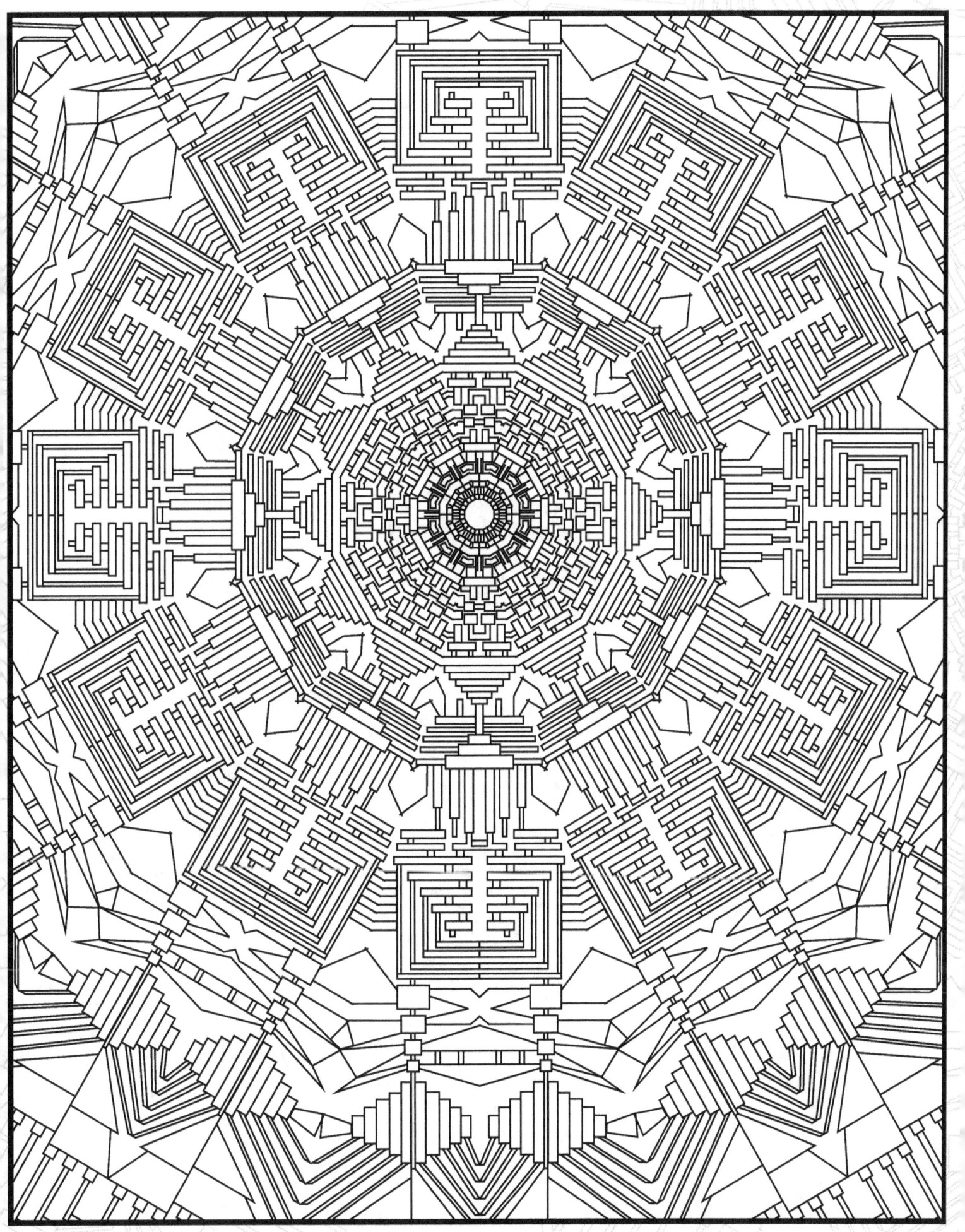

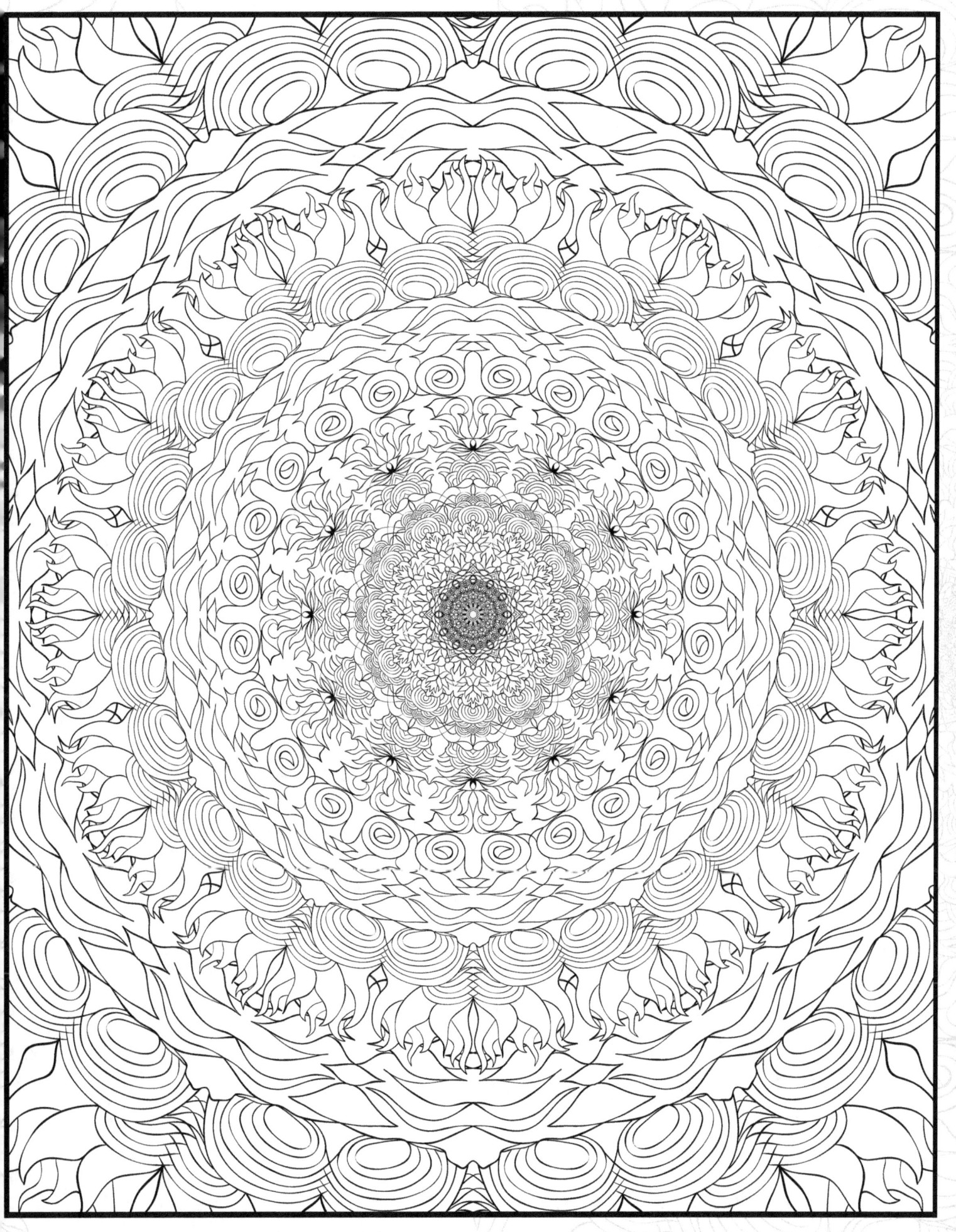

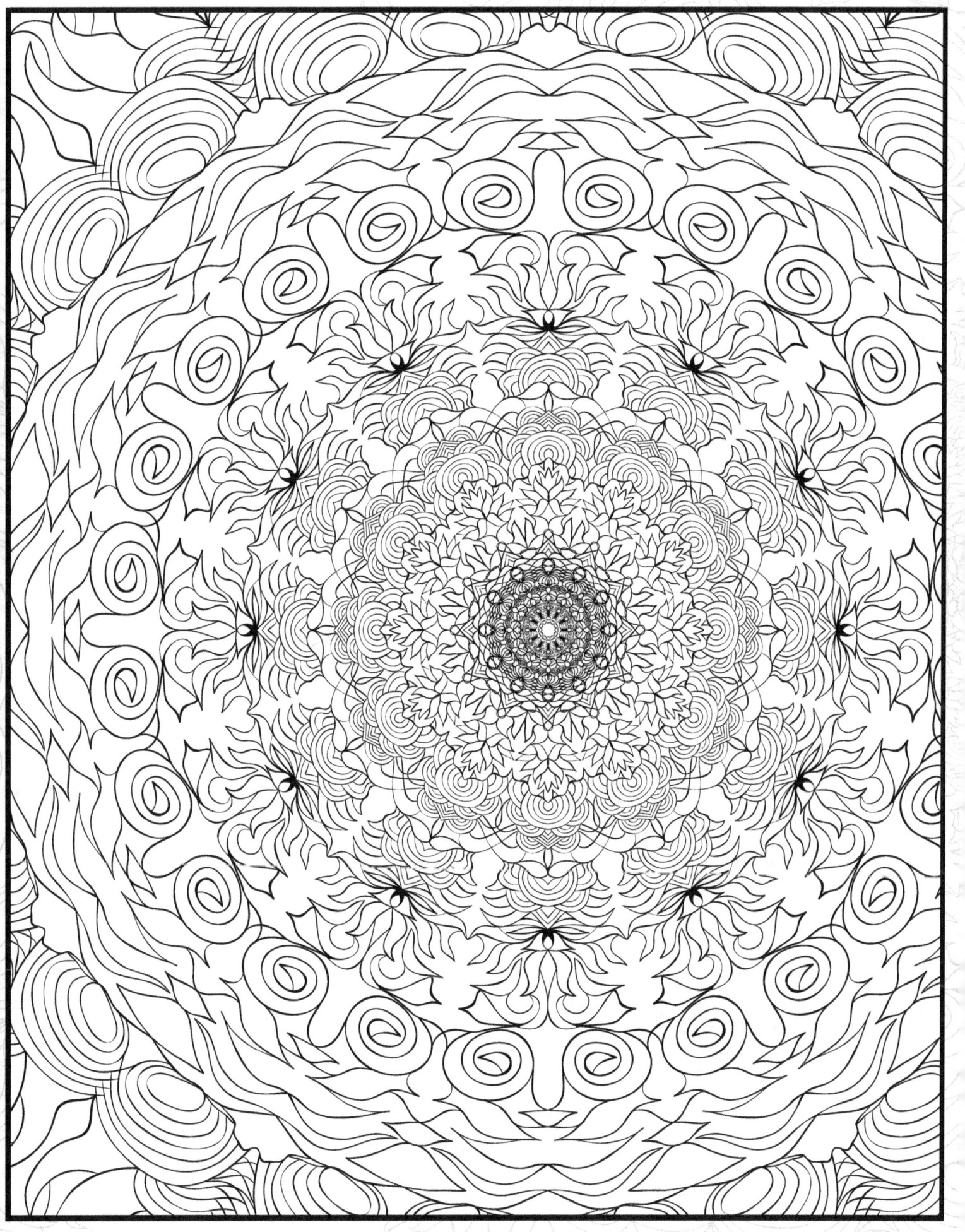

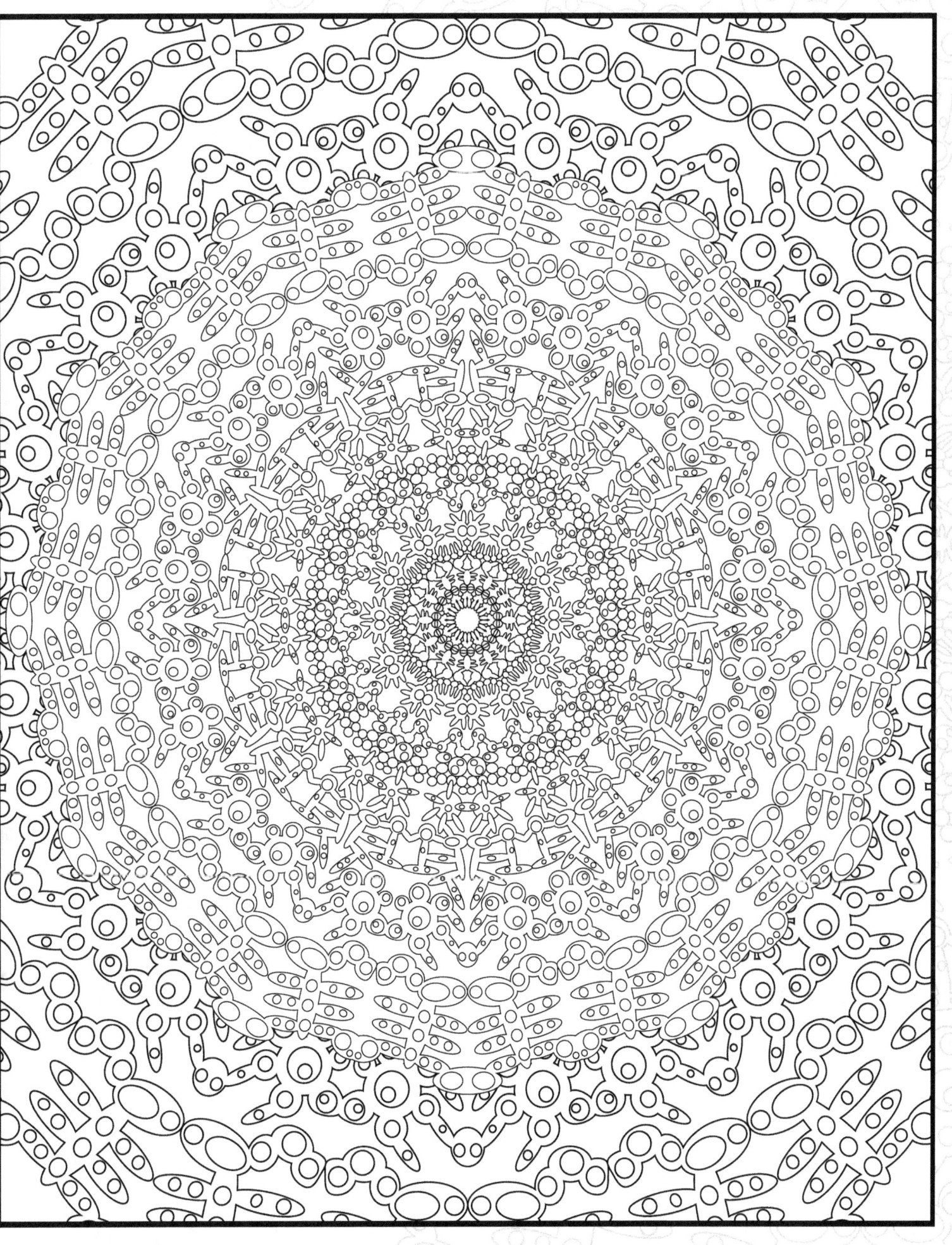

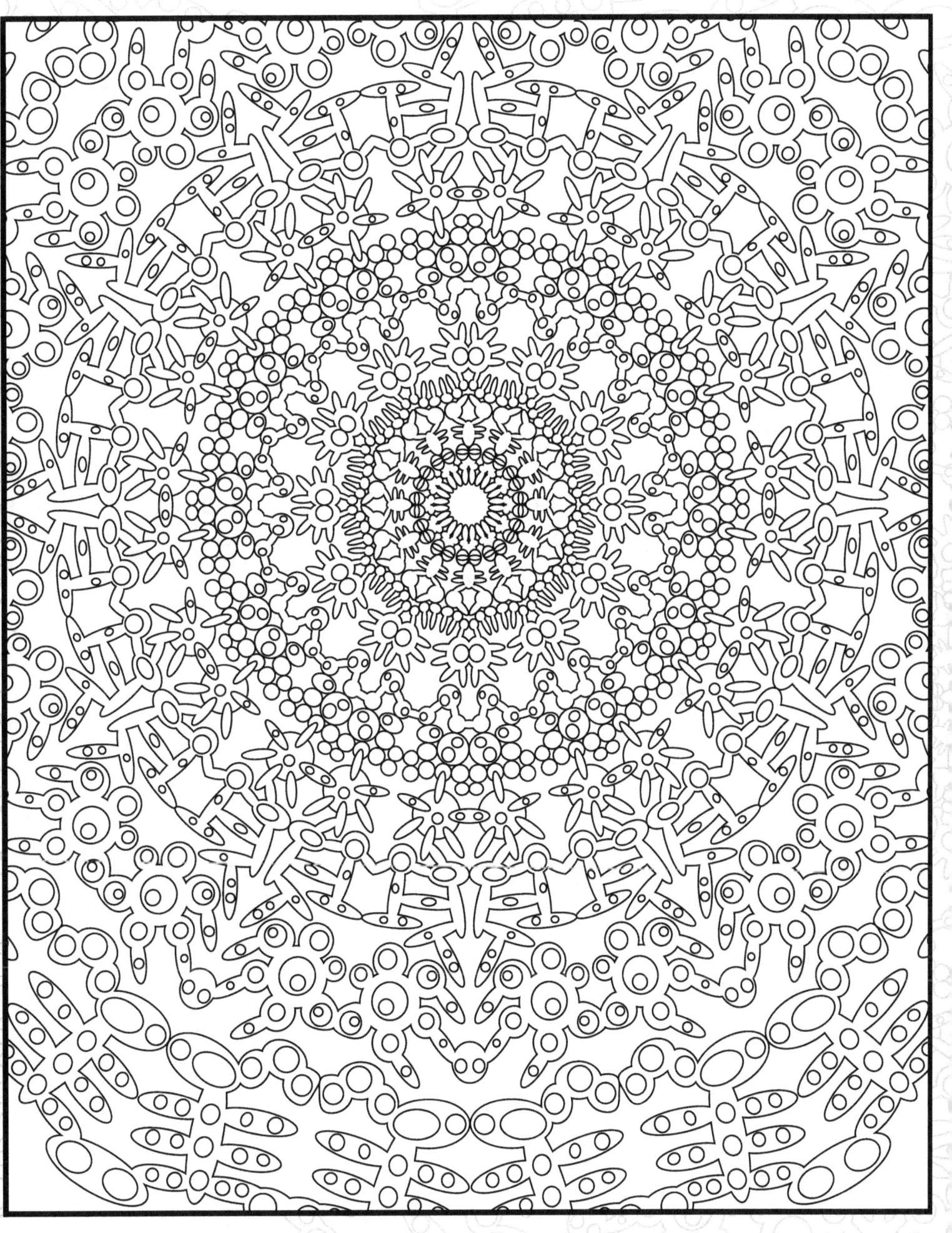

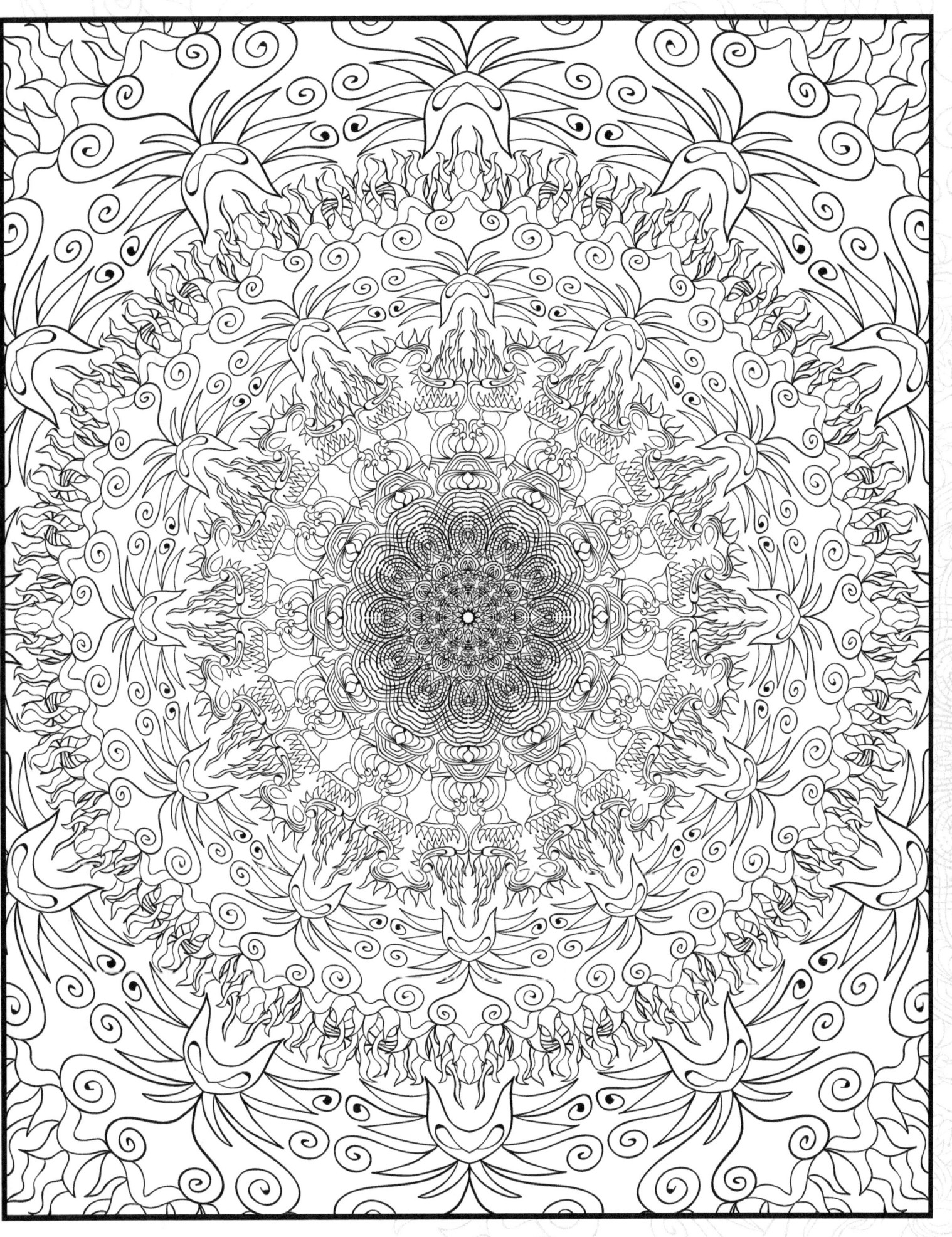

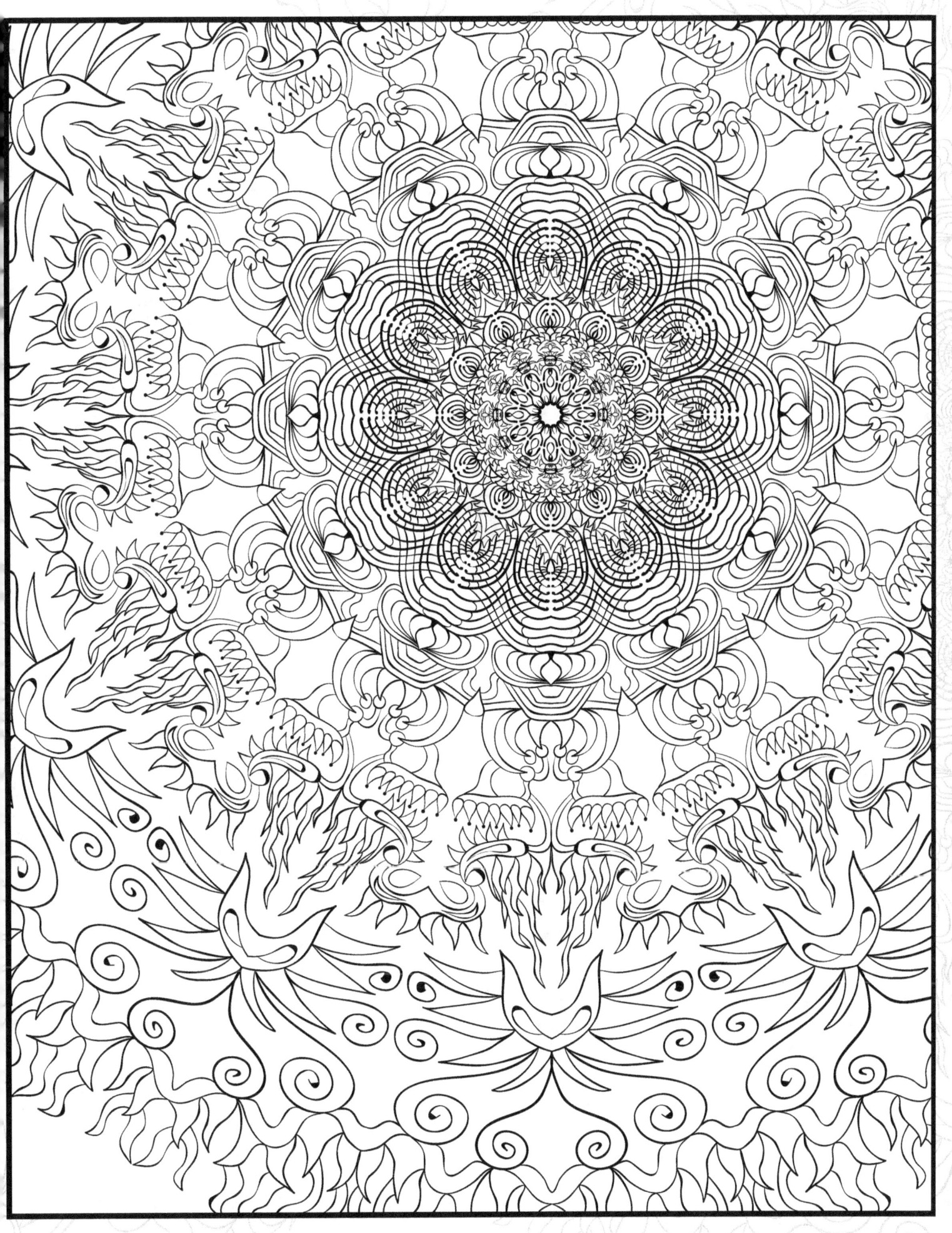

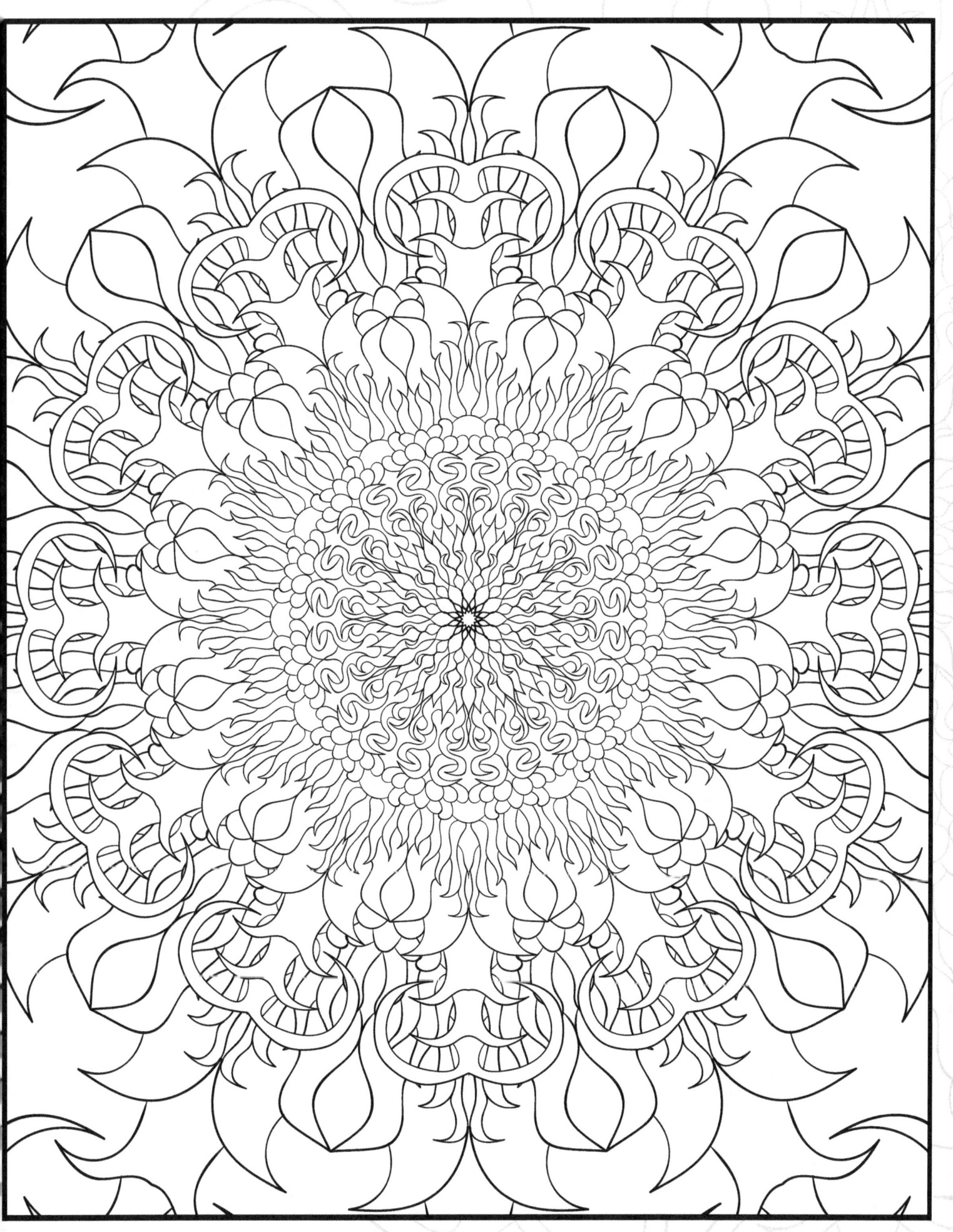

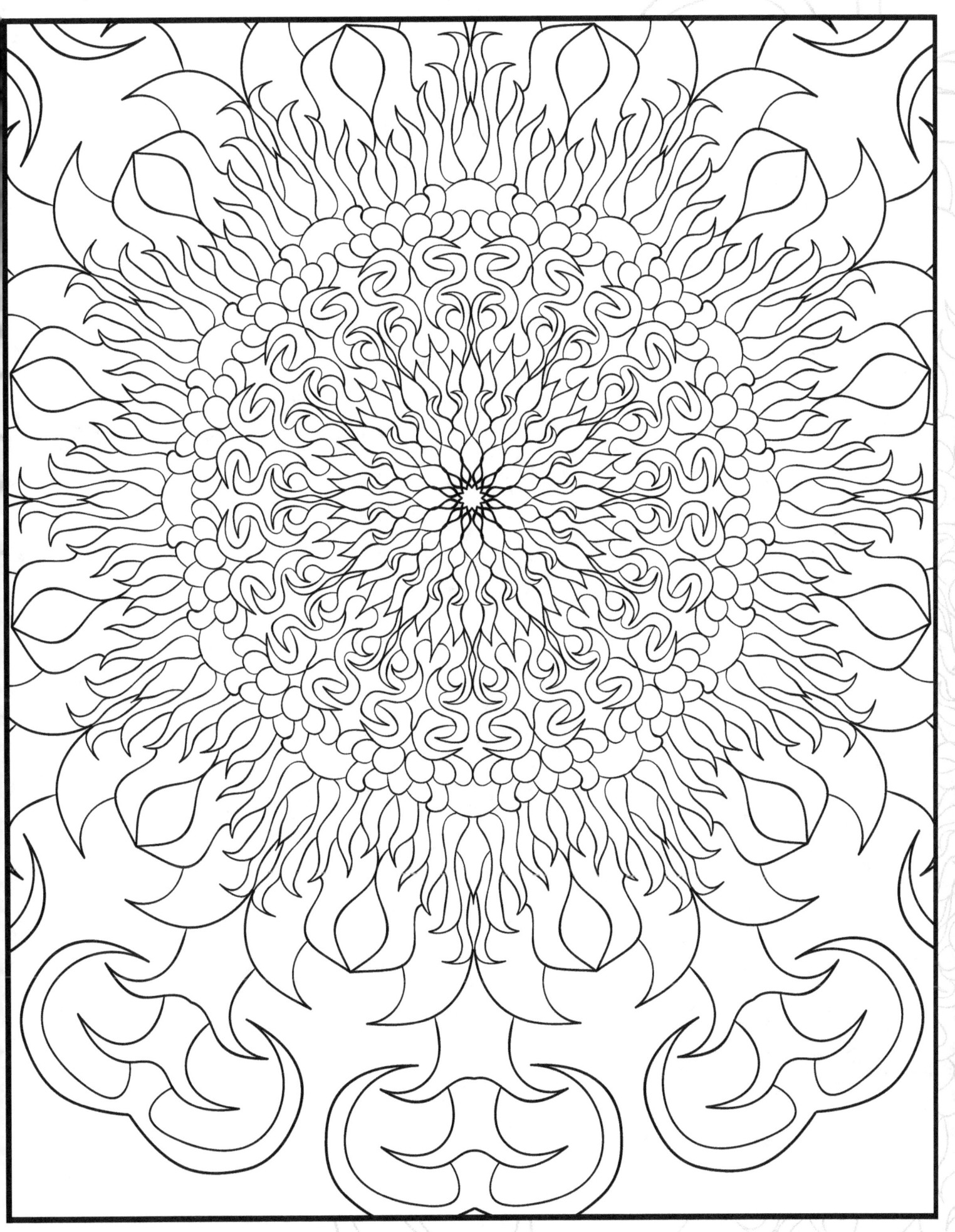

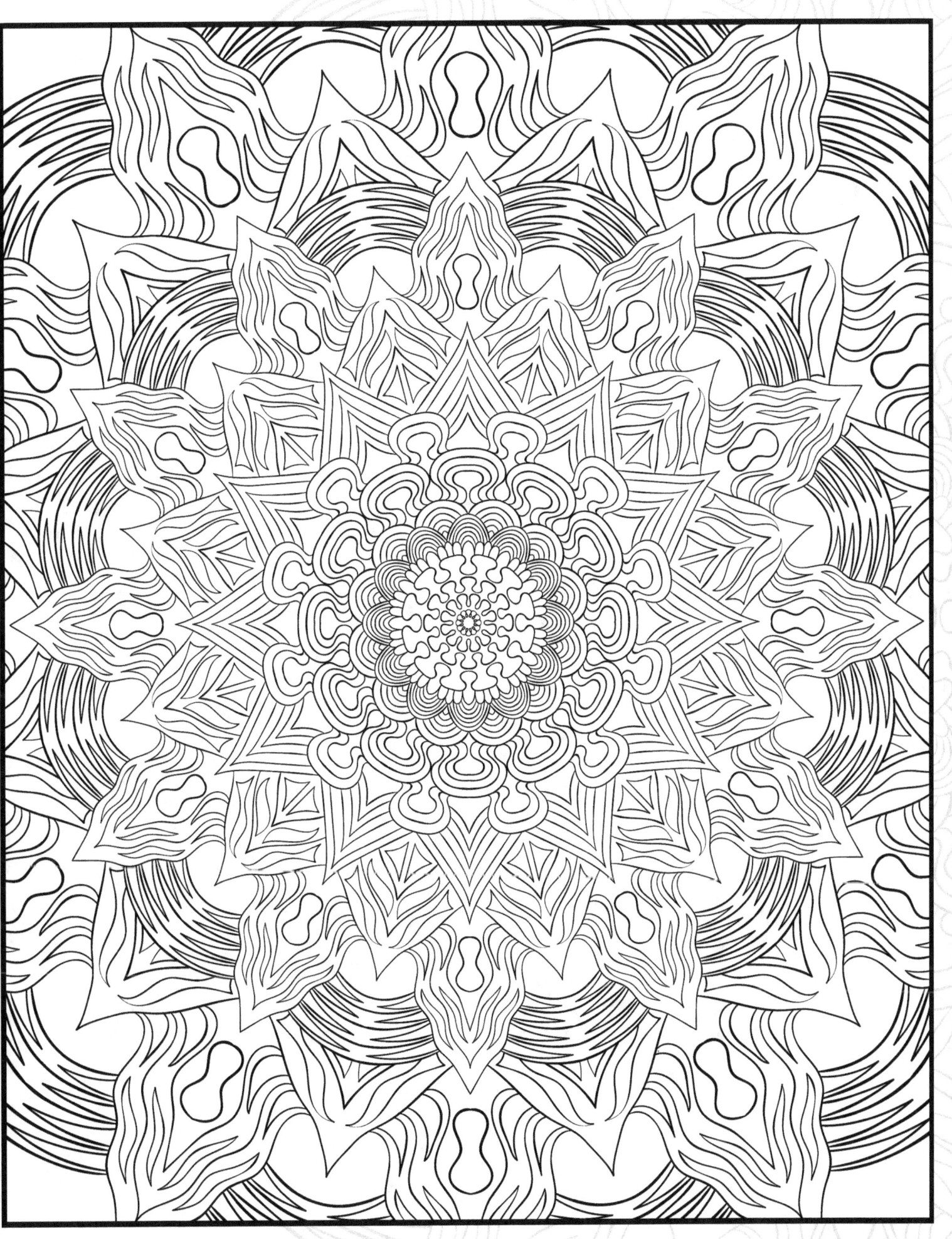

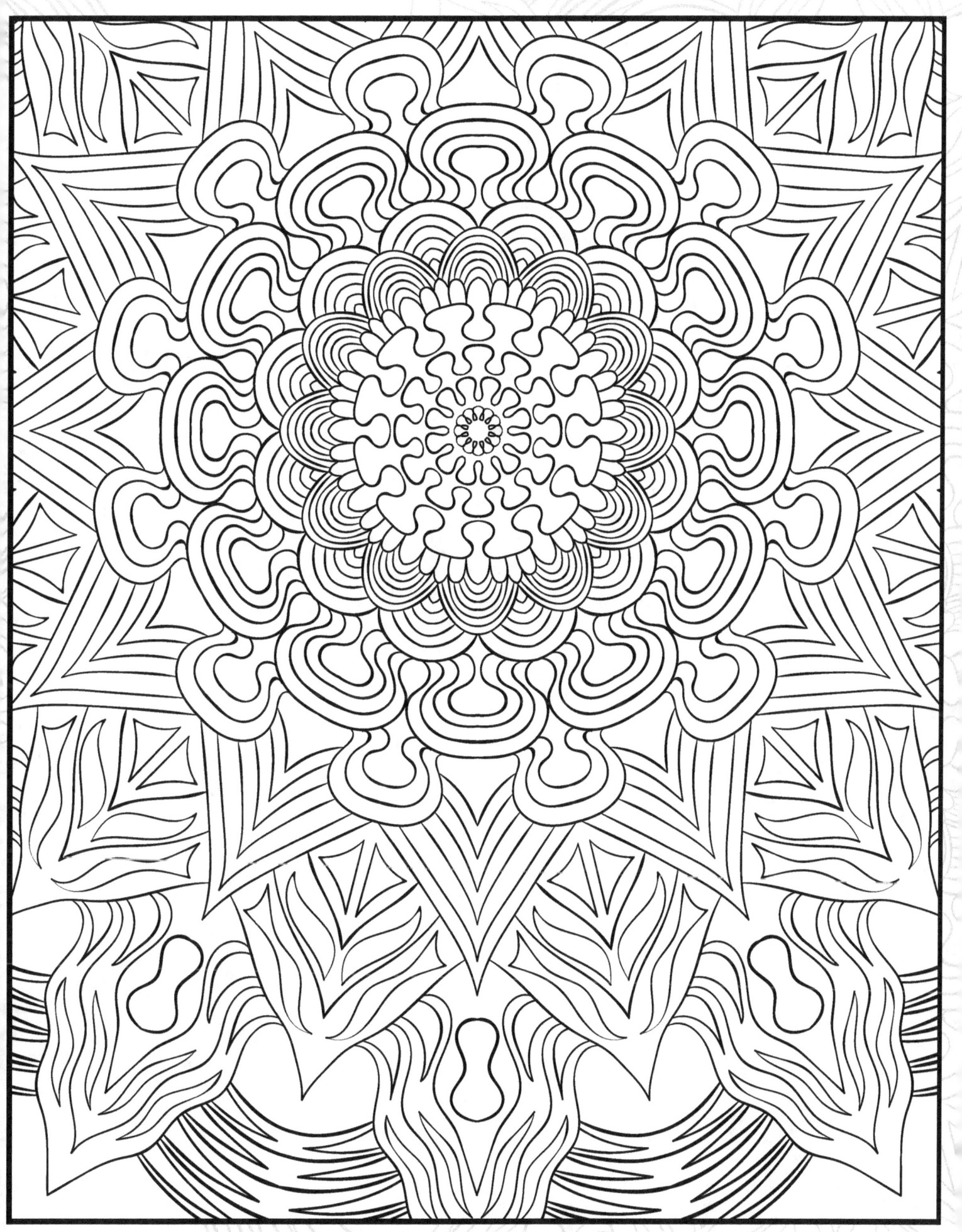

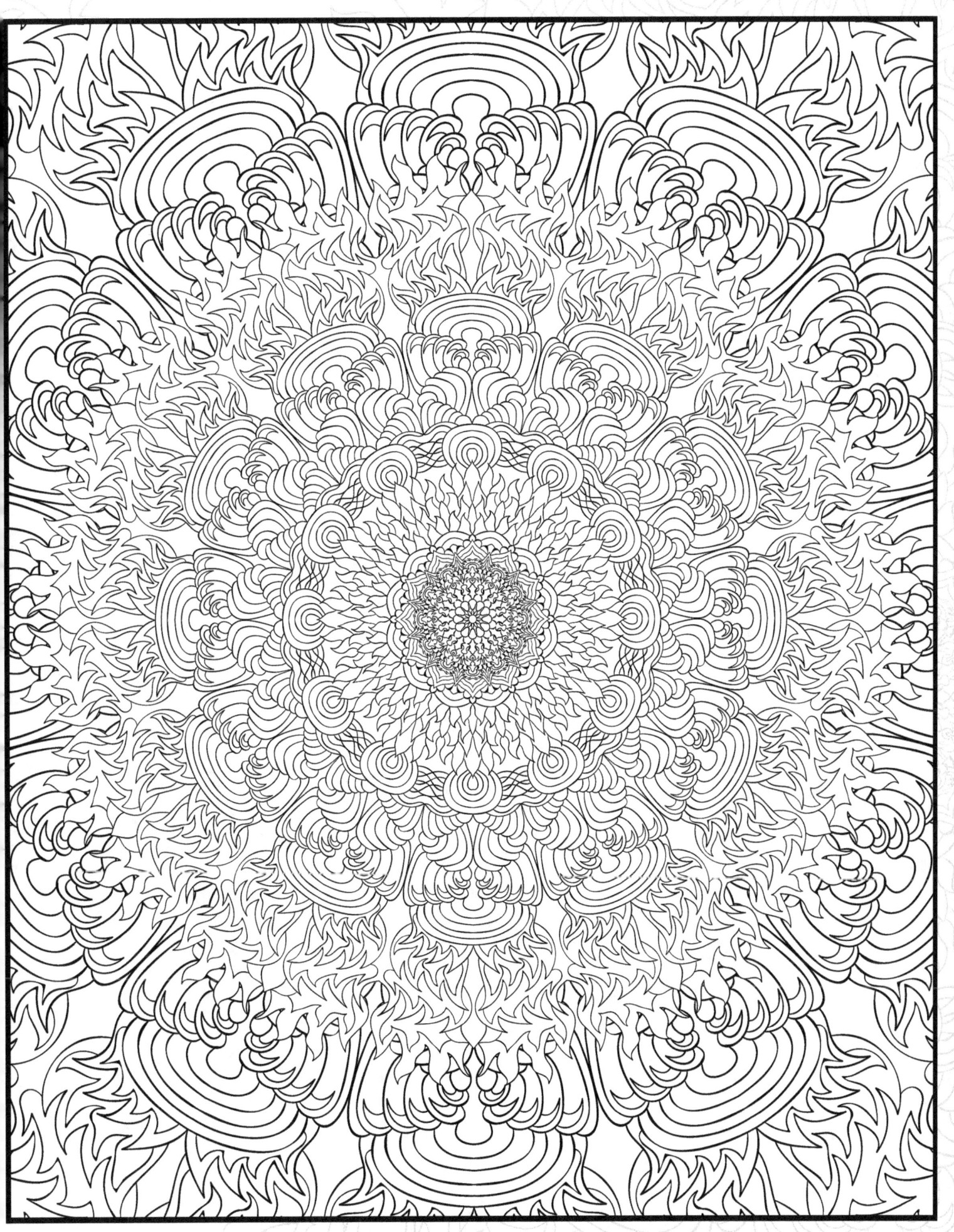

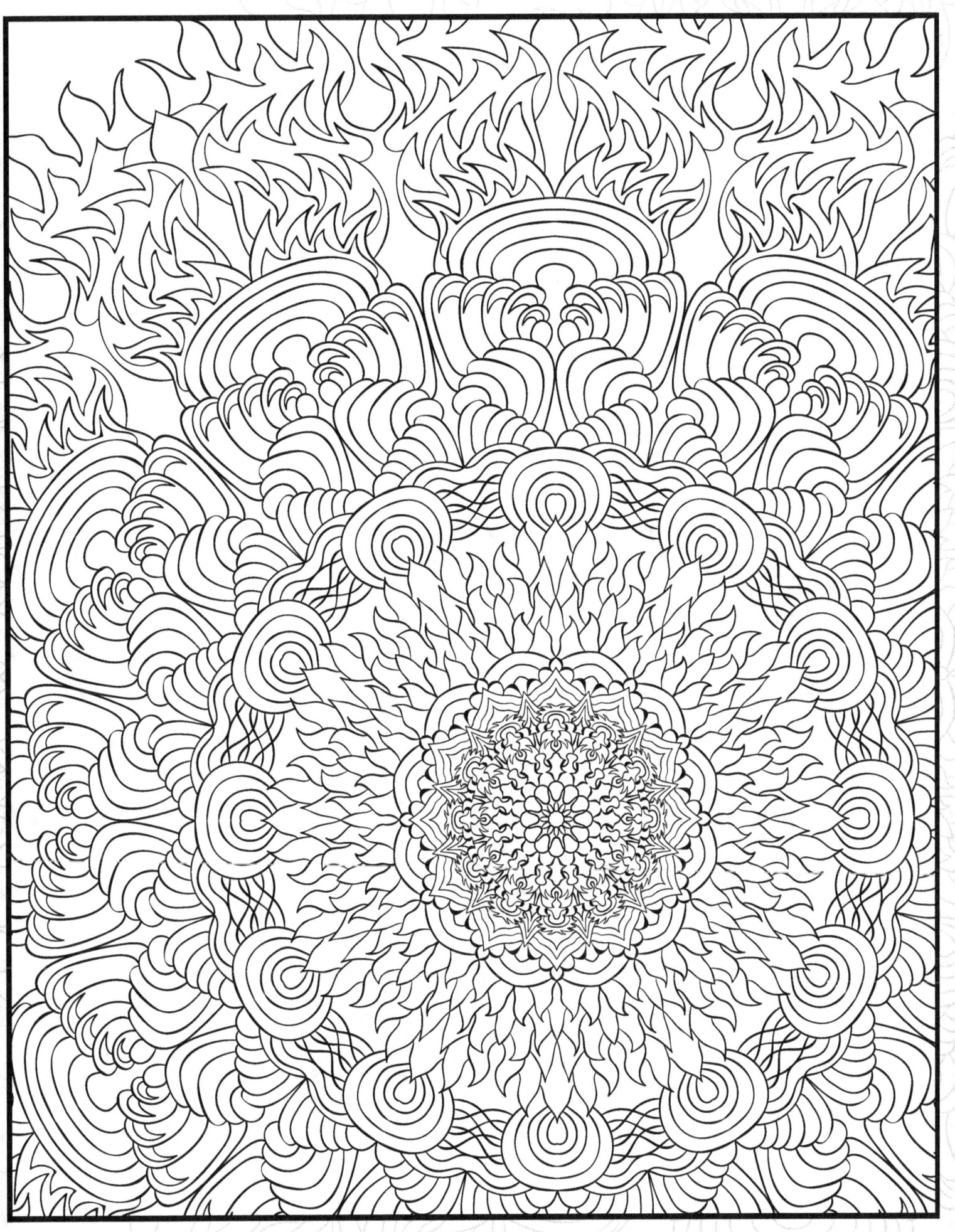

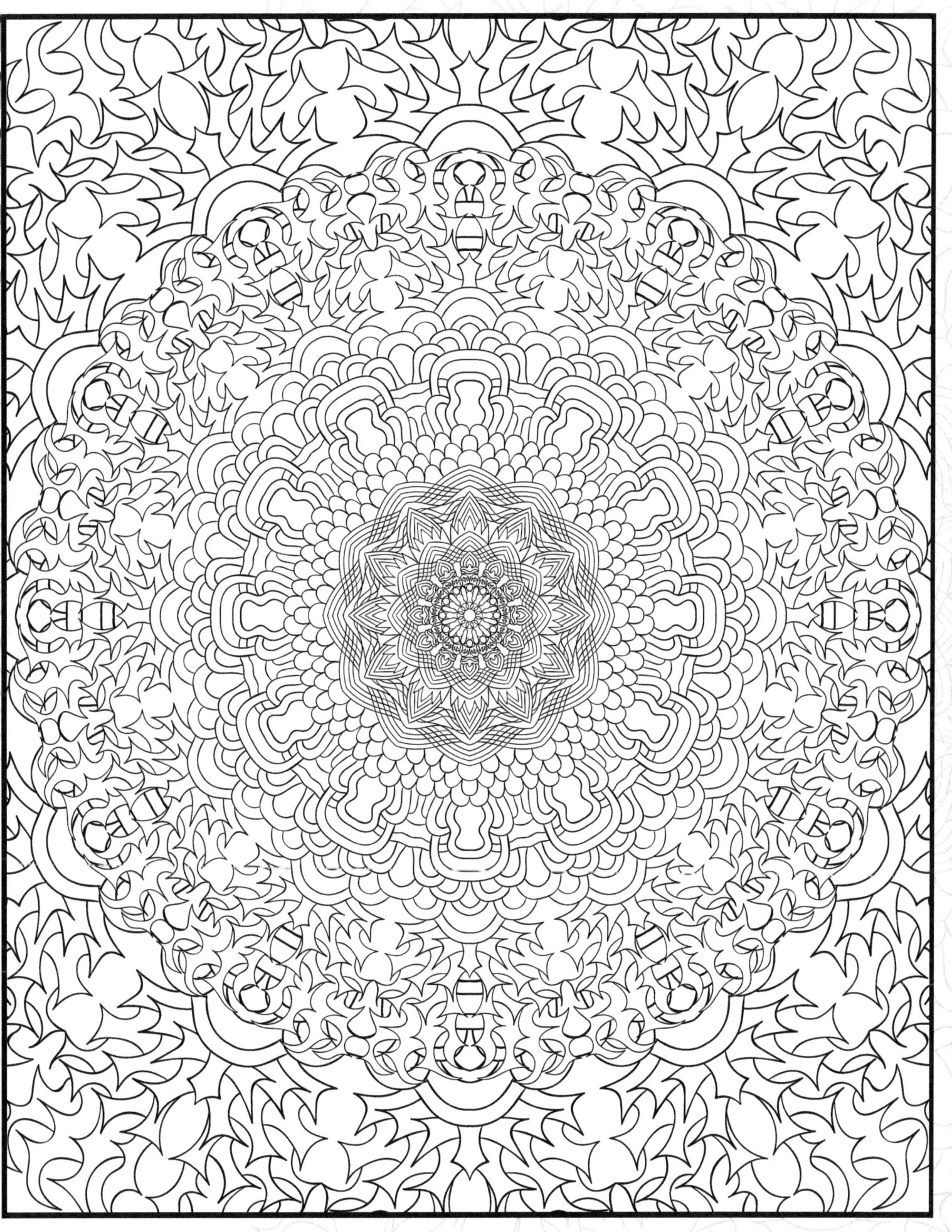

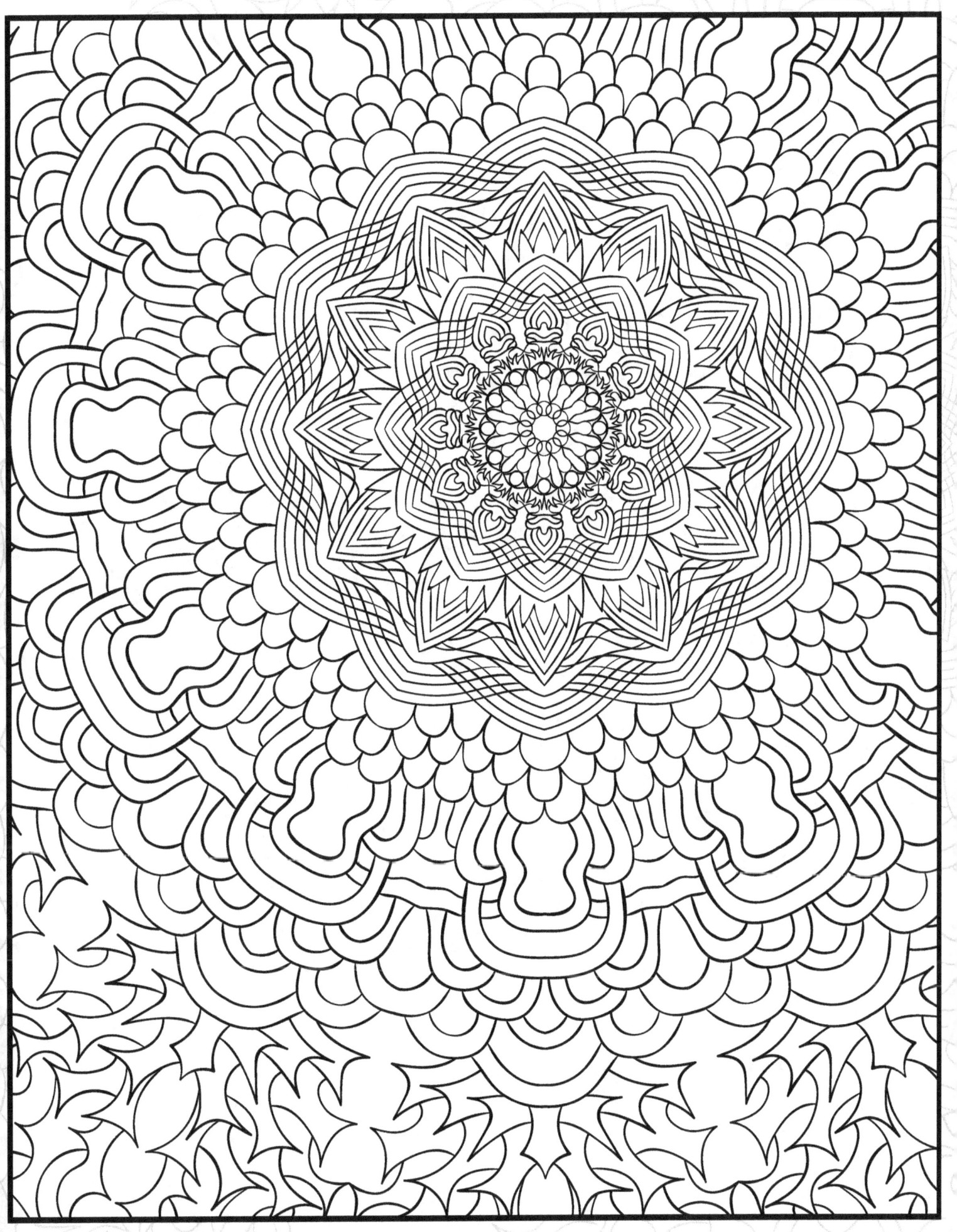

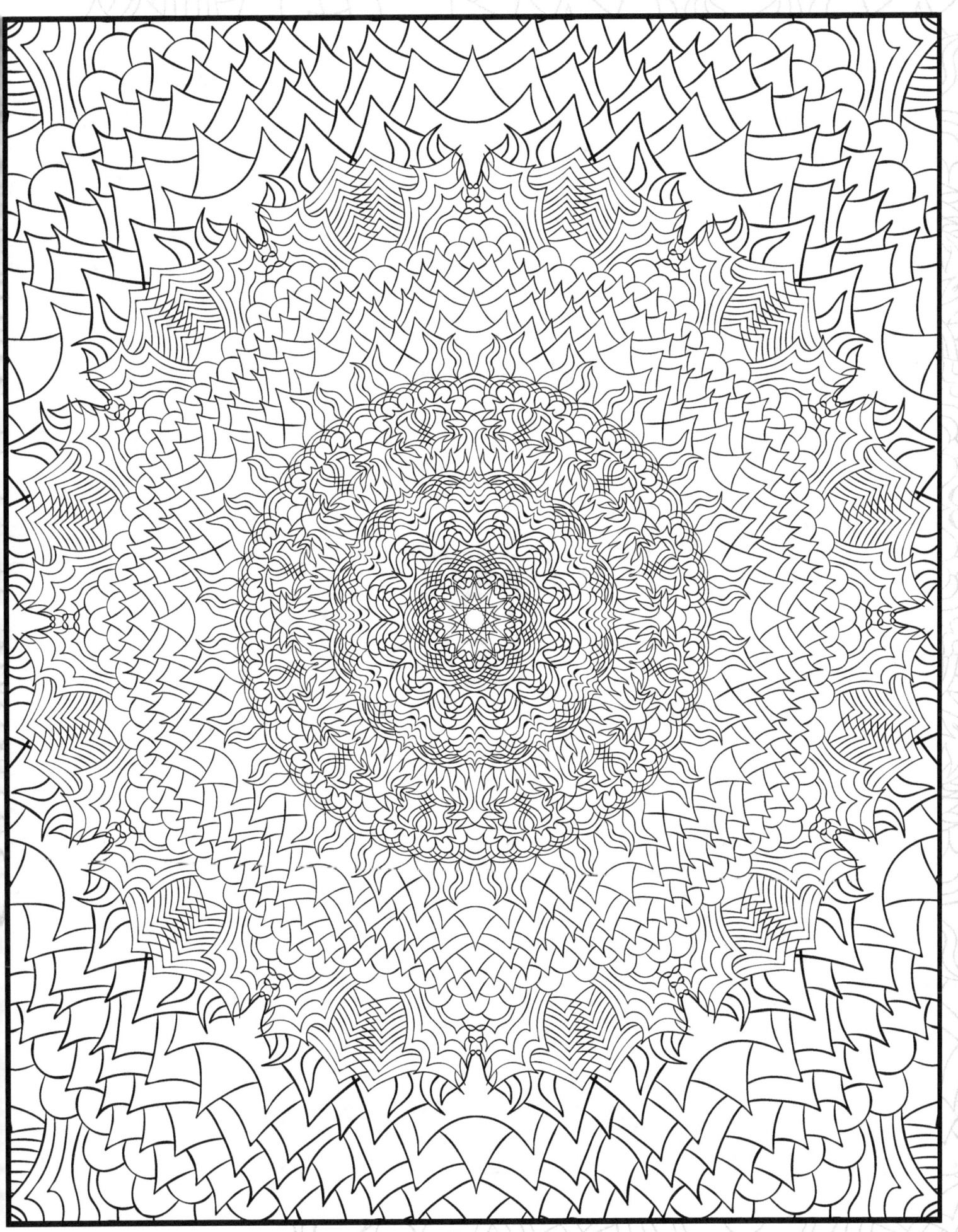

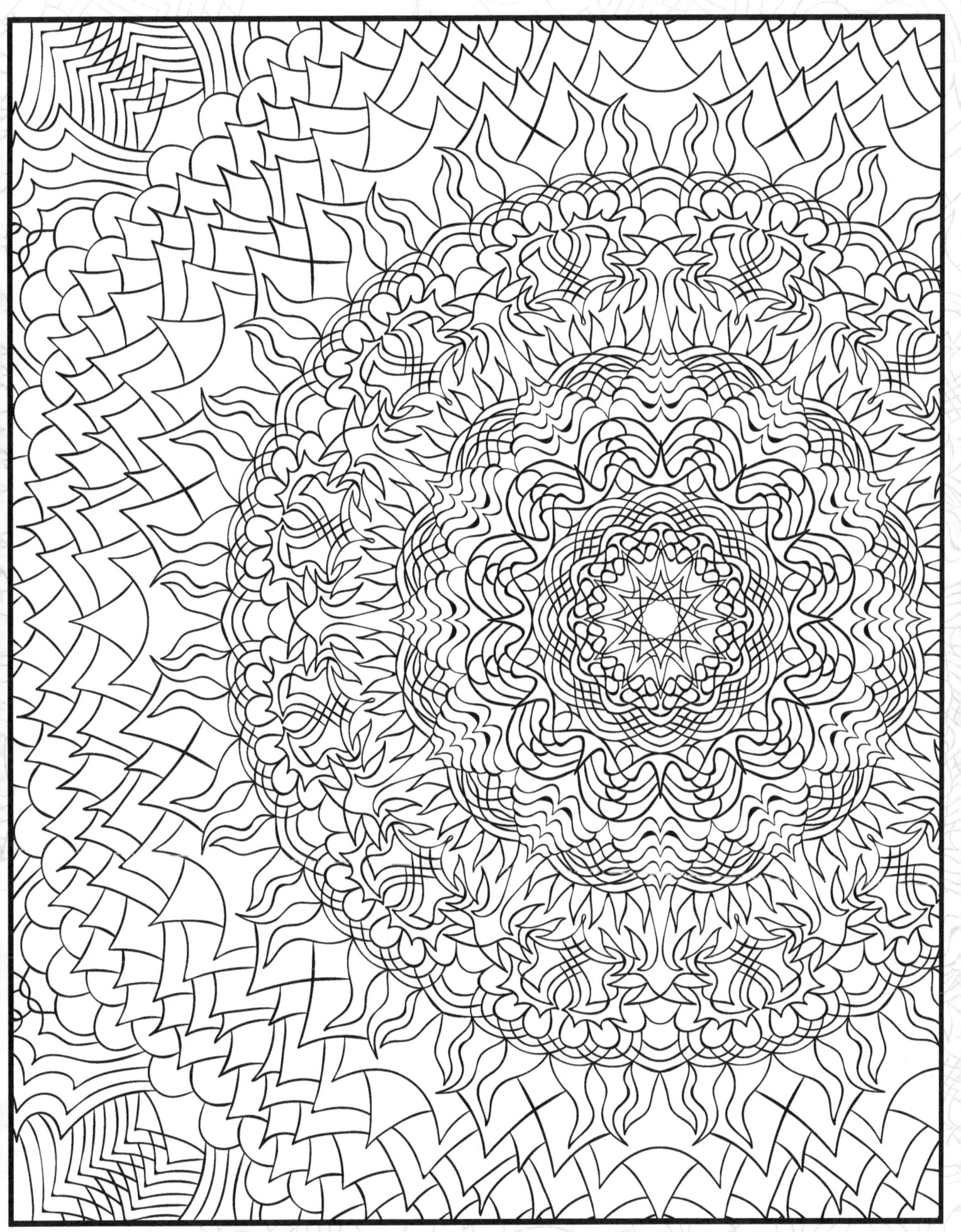

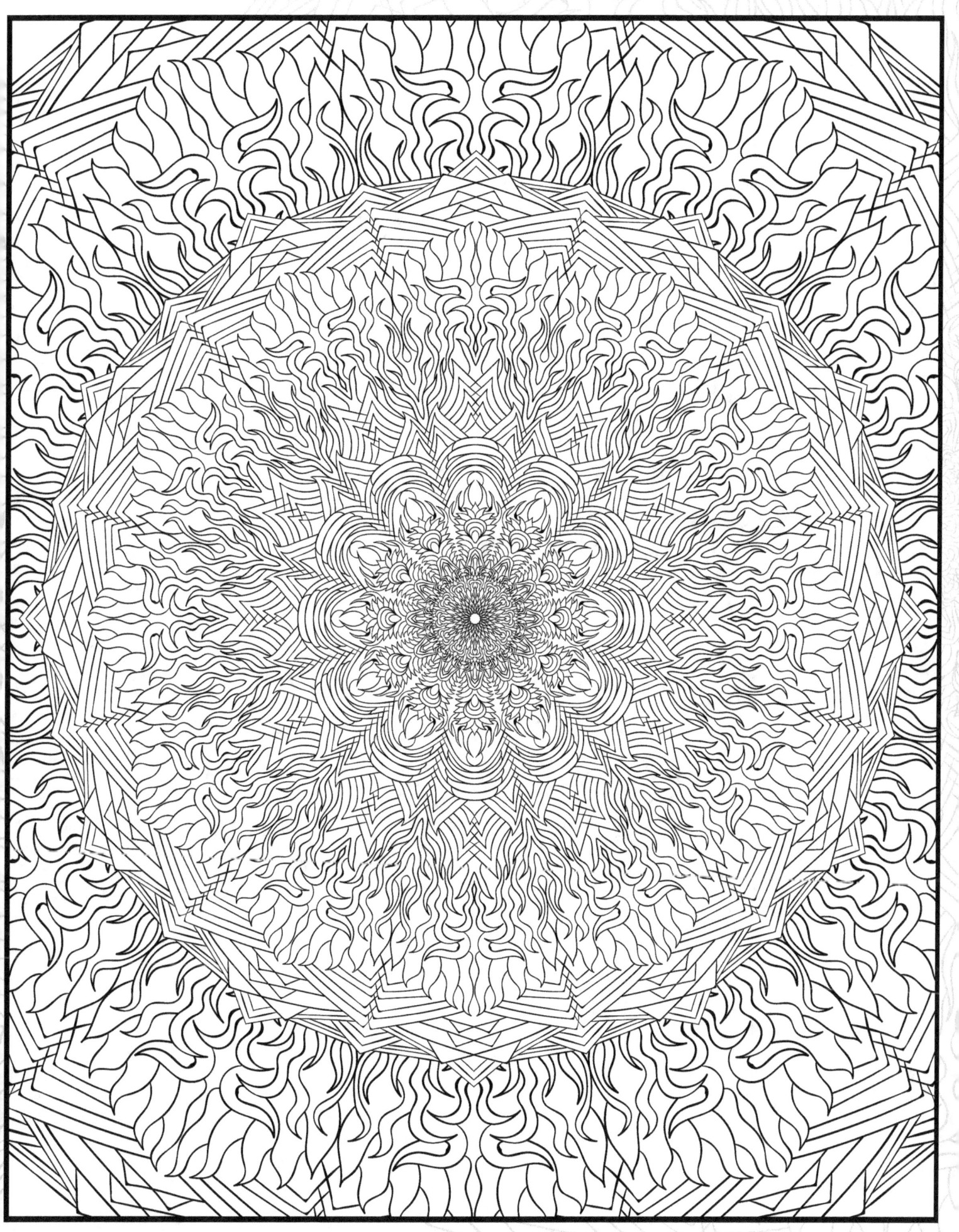

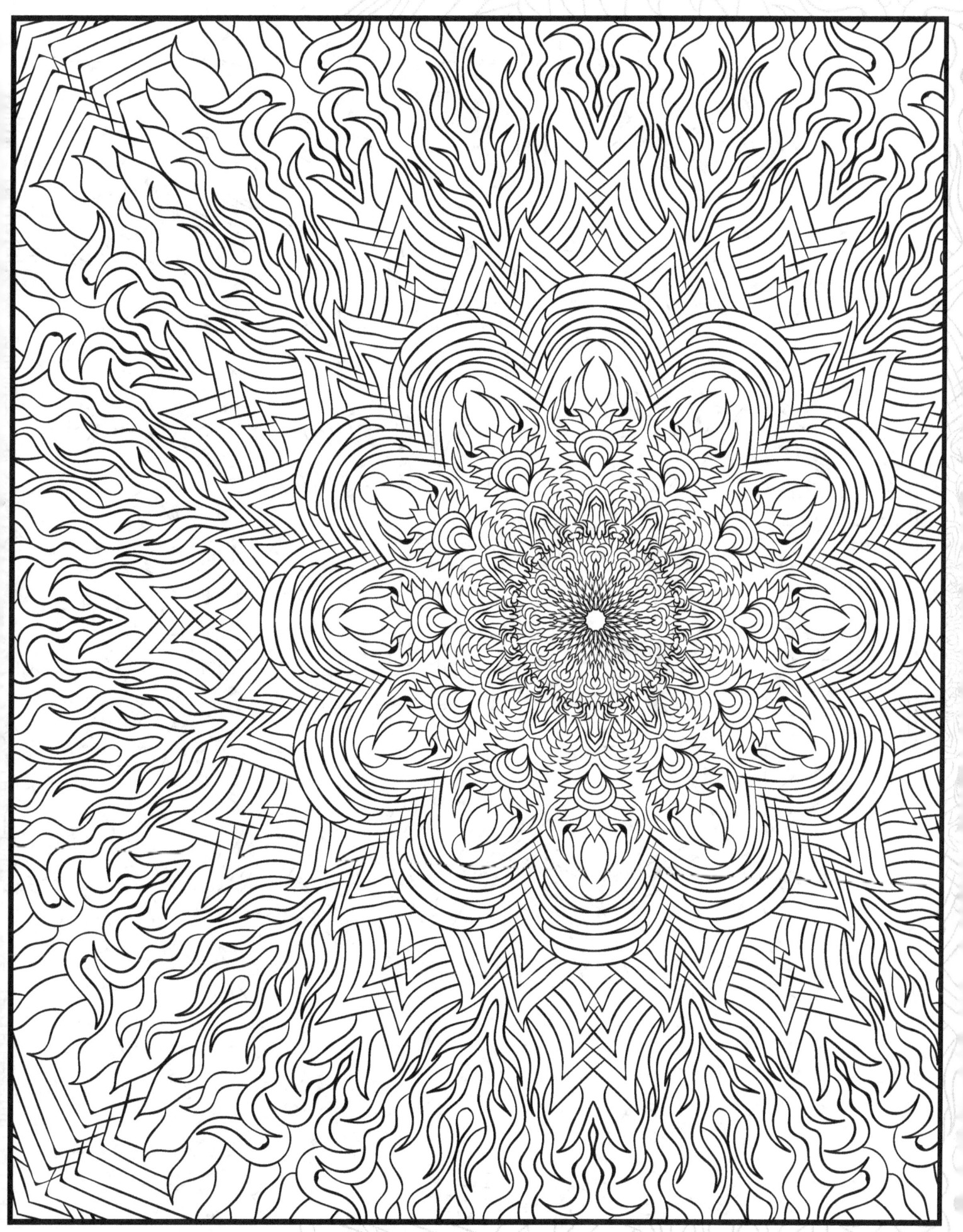

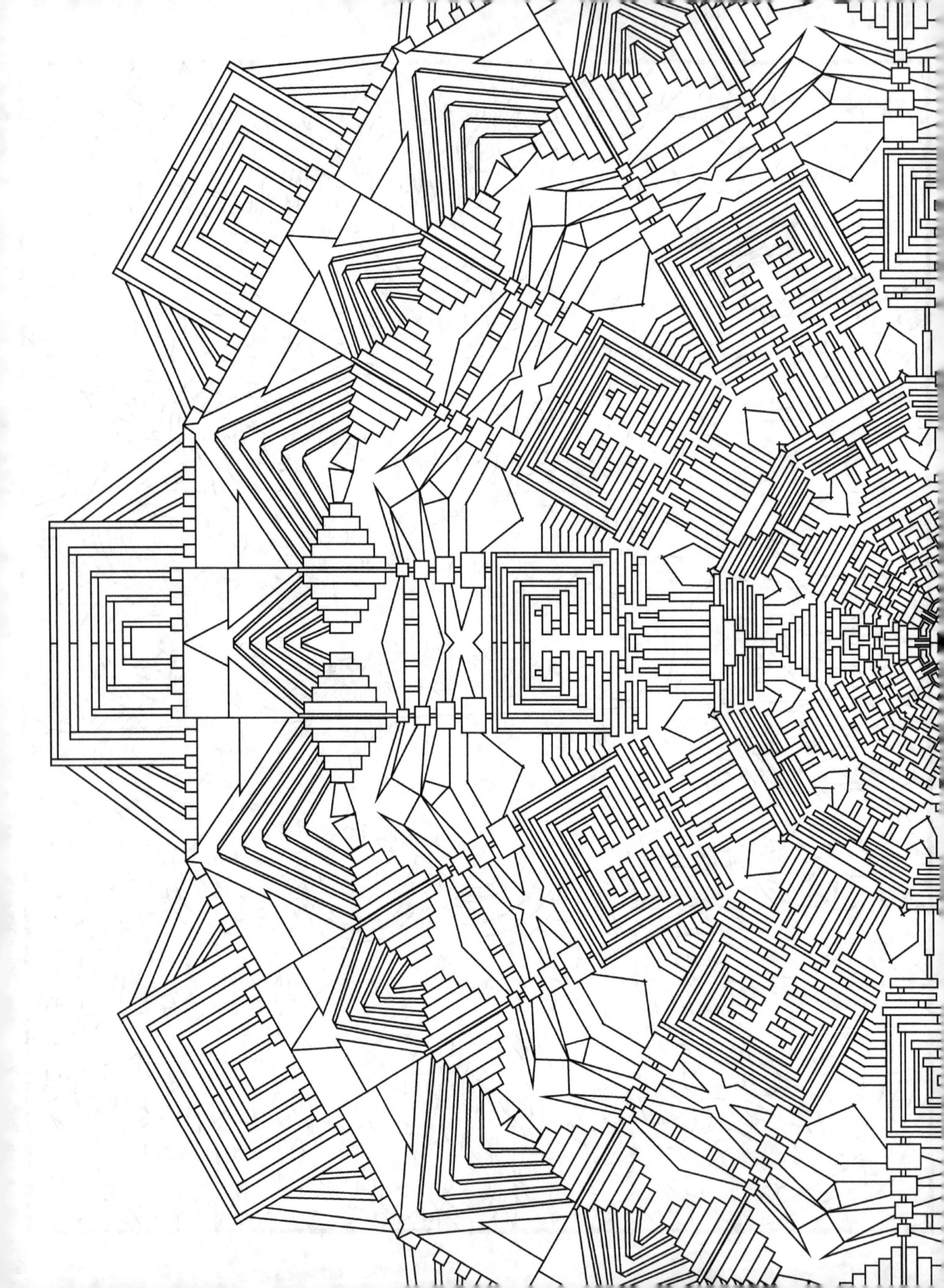

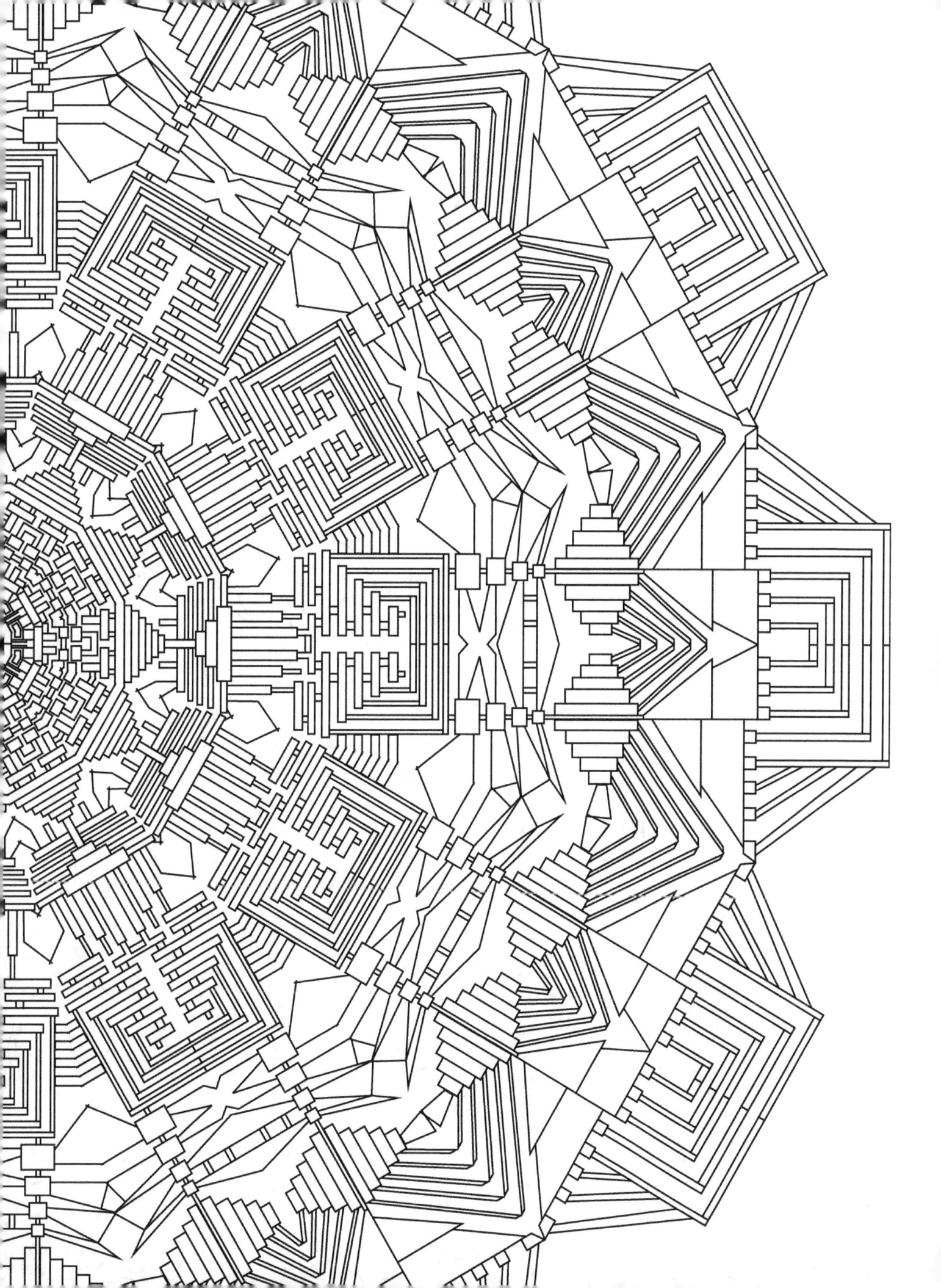

Thank You!

Hope you enjoyed filling this book with colors!

See you in the next one.

www.DKSArt.com

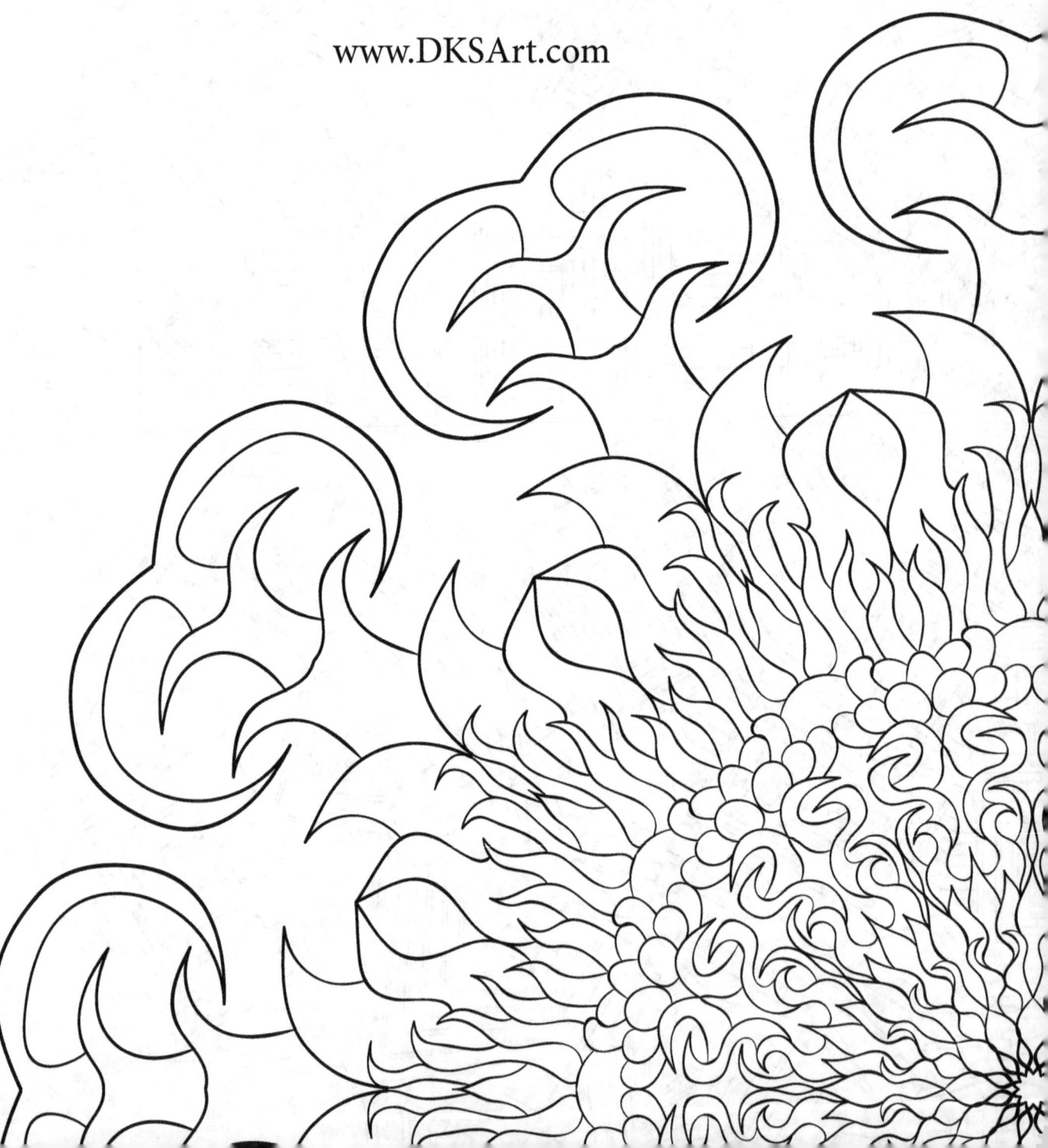

www.ingramcontent.com/pod-product-compliance
Lightning Source LLC
Chambersburg PA
CBHW081459220526
45466CB00008B/2709